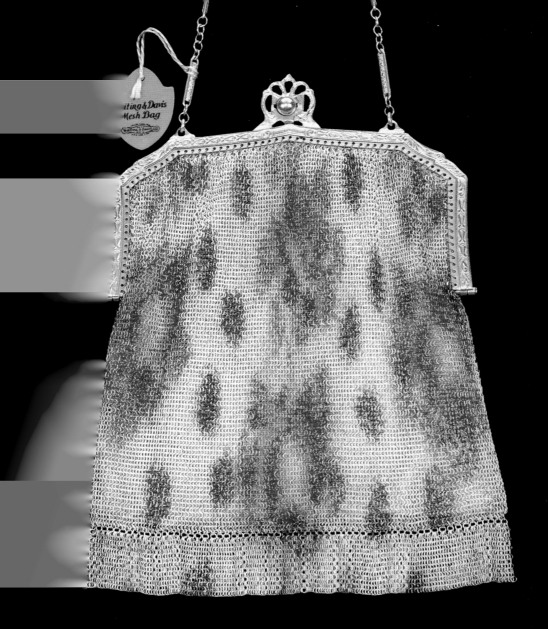

HITING & DAVIS PURSES
The Perfect Mesh

Photography and Design by Leslie Piña
Text by Donald-Brian Johnson

tes:

ndter,

n Foster

ciate: Ramòn Piña

4880 Lower Vall- Road Atglen PA 19310 USA

Dedication

For intrepid and indefatigable researcher Barbara Ward Endter, with gratitude. Your work enhances ours!

Acknowledgments

Our sincere appreciation to the following, who have contributed their collections, expertise, encouragement—or a blend of all three—to *Whiting & Davis Purses: The Perfect Mesh*: Paulette Batt; Susan Berman, Franchi; Lee Bernstein; Brenda Jackson Boyd; Sherie Buck; Barry Cramer; Barbara Ward Endter; Ellen Foster, Vanity Lady; Shirley Friedland; Inge Christopher Accessories; Charles M. Johnson, Sr., and Patricia P. Johnson; Julie, Chuck, and Amanda Kaplan; Hank Kuhlmann; Rebecca Liotard, Indolink; Daniel Cotton, Office Depot Omaha; Tracy Paul, Tracy Paul Public Relations; Ramòn Piña; Lèlia Teixeira, Whiting & Davis Co.; Bunnie Union; Lorita Winfield, and, of course, Peter Schiffer, Nancy N. Schiffer, John P. Cheek, and the staff at Schiffer Publishing. Without each of you, the "mesh" would have been less perfect!

Copyright © 2002 by Leslie Piña and Donald-Brian Johnson
Library of Congress Catalog Control Number: 2002100925

Designed by Leslie Piña
Layout by John P. Cheek
Type set in BernhardModBT/Zurich BT

ISBN: 0-7643-1642-7
Printed in China
1 2 3 4

Published by Schiffer Publishing Ltd.
4880 Lower Valley Road
Atglen, PA 19310
Phone: (610) 593-1777; Fax: (610) 593-2002
E-mail: Schifferbk@aol.com
Please visit our web site catalog at
www.schifferbooks.com
We are always looking for people to write books on new and related subjects. If you have an idea for a book, please contact us at the above address.

This book may be purchased from the publisher. Include $3.95 for shipping. Please try your bookstore first.
You may write for a free catalog.

In Europe, Schiffer books are distributed by
Bushwood Books
6 Marksbury Ave. Kew Gardens
Surrey TW9 4JF England
Phone: 44 (0)20 8392-8585; Fax: 44 (0)20 8392-9876
E-mail: Bushwd@aol.com
Free postage in the UK. Europe: air mail at cost.
Please try your bookstore first.

Contents

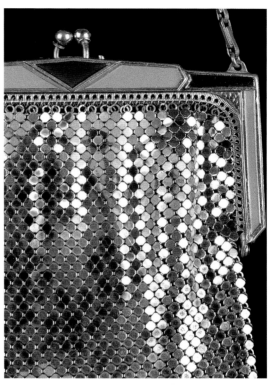

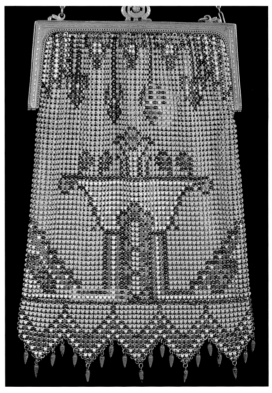

Preface

Prices That Mesh

Truly, a Whiting & Davis Mesh Bag is the very embodiment of queenly beauty, refinement, and utility.
Ladies Home Journal
December, 1923

Expensive then, expensive now. Whiting & Davis mesh bags have always been an extravagant indulgence, whether purchased as a personal treat to be relished, or as a gift that "delicately conveys the esteem and exquisite taste of the giver." Judging from early catalog examples, giving a W & D bag also conveyed that the gift-giver had a bulging pocketbook: in 1927, one Whiting & Davis cigarette/vanity case was offered at $36. *Wholesale*. At the time, this was equivalent to a weekly—or even *monthly*— salary in many areas.

Fortunately for the Whiting & Davis customers of the past, there were also less expensive options, such as the enameled costume mesh bags so popular in the 1920s and '30s. And fortunately for today's collectors, there are degrees of extravagance to be enjoyed in amassing a Whiting & Davis inventory. Not every collection needs to include a $2000-plus Reneè Adoreè "Star Series" bag (well, at least not for awhile, anyway). Numerous enameled armor mesh and Dresden ring mesh purses remain reasonably priced in the $200-300 range, with many lavish Mandalians a bit higher, but still relatively affordable at $300-400.

Pursuing Prices

Price estimates in *Whiting & Davis Purses: The Perfect Mesh* have been been compiled from a variety of sources, and include input from dealers, collectors, and knowledgeable experts in the field, as well as currently realized sale and auction prices. Actual prices may of course vary, based on such intangibles as perceived rarity and desirability, the condition of a specific bag, the dealer, and even the locale. These suggested prices are intended as guidelines only, and are most effective when used as an informed starting point at which to begin negotiations. While we cannot guarantee individual outcomes, we do guarantee that you'll enjoy the mesh purse pursuit!

Although dealing primarily with Whiting & Davis, *The Perfect Mesh* also includes many of the equally popular Mandalians, as well as representative samplings from other manufacturers. The provenance of any bag specified as by a particular maker has been verified by the presence of a logo, label, or other identifying marker. When not specified, a bag can be presumed to be by Whiting & Davis (or, where applicable, by Mandalian).

"Mesh"-uring Up

Price estimates given are for bags in "excellent" condition, defined here as:
* no damage to the mesh
* no damage to any enameling on the mesh
* no damage to the frame, or any frame decoration
* no damage to fringe, drops, or any other trim decor
While many mesh bags today are found with torn or otherwise unsuitable linings, lining condition has not be used a price

determinant. Linings can easily be replaced, and in many cases doing so will enhance the bag's usability and overall appeal.

Also adding to the appeal and monetary value of a mesh bag is the care taken in its display and upkeep. Bags piled together carelessly will sooner or later develop snags or rips in the mesh. In bygone days, jewelers had the luxury of displaying their W & D wares on long-gone company-supplied "WADCO Easels." Today's collectors can make do just as nicely with wall hooks. These not only allow the bags to be displayed individually, but also add a uniquely colorful, and ever-changing scenic background to the room in which they are displayed.

Mesh bags are made of metal tiles or rings, both prime dust collectors. Regular dusting with a fine, soft brush will keep the colors bright, and the patterns recognizable. Many mesh bags are also enameled; to keep the colors fresh and unfaded, display or store the bags out of the path of direct sunlight.

Added Attractions

Just as damage or deterioration will detract from the value of a bag, unusual or additional features will add to it. Among the "pluses" to look for:
* Fringe, drops, or fringe *and* drops. (Since so many Mandalians have one or the other—or both—this explains the higher prices they generate)
* Finer mesh—baby ring mesh, or baby flat mesh—which has a silkier feel, and greater pliancy
* Precious metals or jewels used in the bag construction or decor
* Figural or scenic depictions, if clear and unfaded
* Frame embellishments, such as extensive enameling or openwork
* Bags with supplementary or dedicated functions, such as compact purses and children's bags
* "Add-ons": pull-bead handles, jewel-studded frames, Bakelite clasps, and the like
* "Designer" bags, created by such prominent fashion names as Elsa Schiaparelli and Paul Poiret
* Dresdens in vivid, unfaded colors
* Special commemoratives, such as the 1933 World's Fair souvenir bag, and the 1976 "Star Series" set
* Bags still possessing their original labels, tags, boxes, display cards, or similar support materials. (These will not only add to the monetary value of your Whiting & Davis bag, but to its historical value as well.)

Here Today, There Tomorrow

As with any fashion item, taste in mesh is cyclic, with different stylings and treatments falling in and out of favor. Currently, highly decorated, heavily trimmed Whiting & Davis and Mandalian bags are at the top of the price ladder, with rectangular, beadlite, and hazily-defined abstract-patterned bags a few rungs further down (good news for those looking to build a collection of rectangular beadlite bags in hazy abstracts.) By next year, however, the winds may have shifted, and those Reneè Adoreè bags will be so affordable, you'll want to snap up two. If you can find them.

Whiting & Davis Mesh Bags: "Gifts That Last"

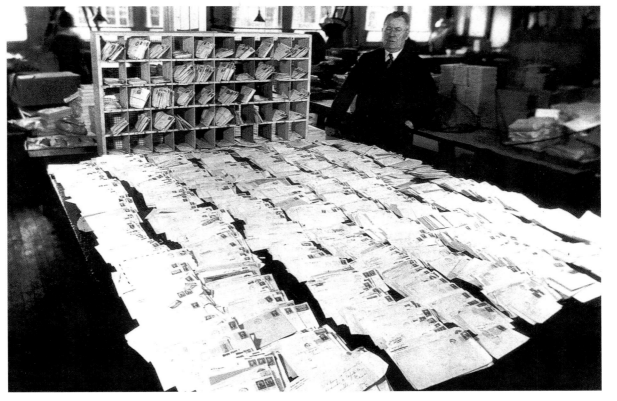

Extremely successful was W & D's "free coin purse" offer of 1925. Complete a coupon, add a quarter for shipping, and a Whiting & Davis mesh coin purse was yours! Here, Mr. Whiting surveys *one day's* worth of responses.

Holiday 2000 / Spring 2001

A current Whiting & Davis catalog cover, colorfully arranged to catch the eye.

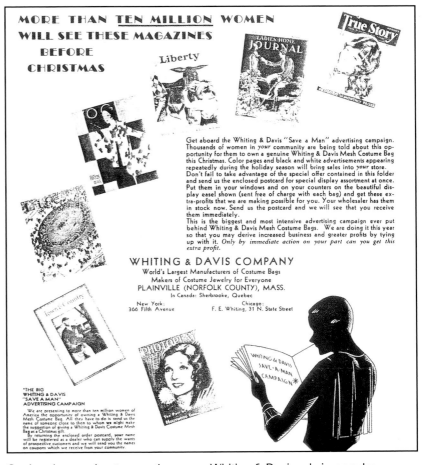

MORE THAN TEN MILLION WOMEN WILL SEE THESE MAGAZINES BEFORE CHRISTMAS

Get aboard the Whiting & Davis "Save a Man" advertising campaign. Thousands of women in *your* community are being told about this opportunity for them to own a genuine Whiting & Davis Mesh Costume Bag this Christmas. Color pages and black and white advertisements appearing repeatedly during the holiday season will bring sales into *your* store. Don't fail to take advantage of the special offer contained in this folder and send us the enclosed postcard for special display assortment at once. Put them in your windows and on your counters on the beautiful display easel shown (sent free of charge with each bag) and get these extra-profits that we are making possible for you. Your wholesaler has them in stock now. Send us the postcard and we will see that you receive them immediately.

This is the biggest and most intensive advertising campaign ever put behind Whiting & Davis Mesh Costume Bags. We are doing it this year so that you may derive increased business and greater profits by tying up with it. *Only by immediate action on your part can you get this extra profit.*

WHITING & DAVIS COMPANY
World's Largest Manufacturers of Costume Bags
Makers of Costume Jewelry for Everyone
PLAINVILLE (NORFOLK COUNTY), MASS.
In Canada: Sherbrooke, Quebec

New York: Chicago:
366 Fifth Avenue F. E. Whiting, 31 N. State Street

Getting the word out: over the years, Whiting & Davis ads in popular magazines have resulted in multitudes of buyers. This clever "Save A Man" campaign of the late 1920s encouraged readers to "send us the name of someone close to you to whom we might make the suggestion of giving a Whiting & Davis Costume Mesh Bag as a Christmas gift." Hmmmm, no pressure there!

Buyers could always make sure they were getting what they were paying for by checking for the Whiting & Davis logo. First used in 1921 and registered in 1922, this trademark became, in the words of a 1926 company news release, "that evidence of stability and confidence that no money on earth can purchase".

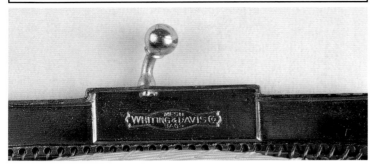

The Whiting & Davis trademark, incised in a mesh bag frame.

Blue velvet jewel case, stamped with the W & D logo.

The Whiting & Davis logo hang tag, a common feature on many mesh bags.

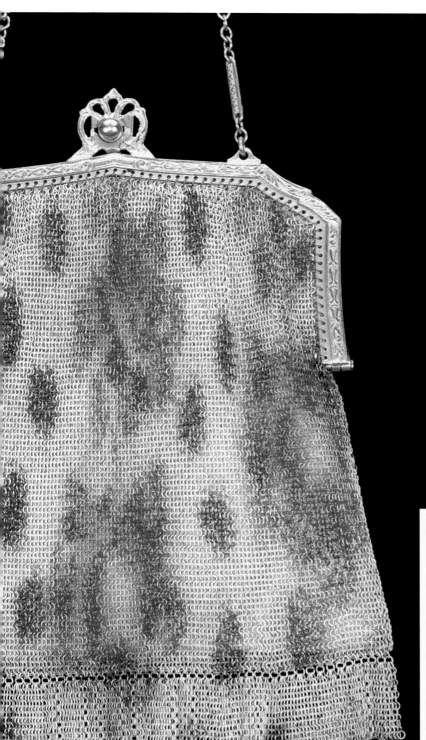

A Whiting & Davis Dresden mesh bag with "Blue" tag still in place. $250-300.

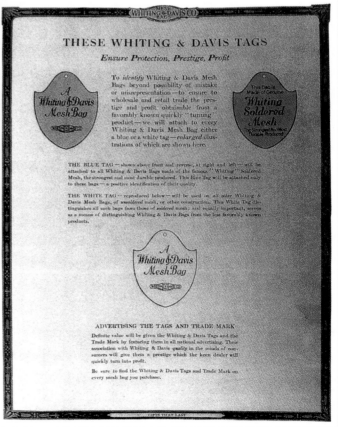

A less permanent Whiting & Davis marker: the "shield tag". Designed to "identify Whiting & Davis mesh bags beyond possibility of mistake or misrepresentation", it came in two varieties. The "Blue" tag, shown front and reverse at top, indicated a soldered mesh bag. The "White" tag at bottom was attached to all other Whiting & Davis mesh bags, "distinguishing them from the less favorably known products".

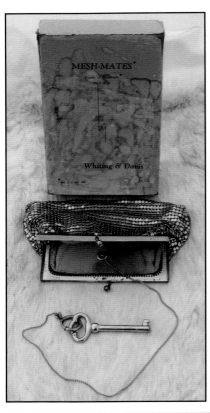

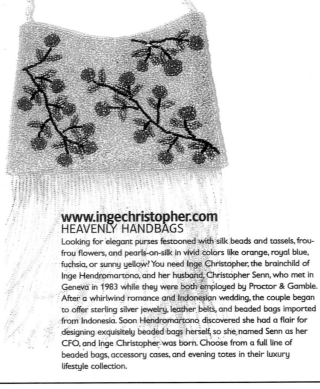

www.ingechristopher.com
HEAVENLY HANDBAGS

Looking for elegant purses festooned with silk beads and tassels, frou-frou flowers, and pearls-on-silk in vivid colors like orange, royal blue, fuchsia, or sunny yellow? You need Inge Christopher, the brainchild of Inge Hendromartono, and her husband, Christopher Senn, who met in Geneva in 1983 while they were both employed by Proctor & Gamble. After a whirlwind romance and Indonesian wedding, the couple began to offer sterling silver jewelry, leather belts, and beaded bags imported from Indonesia. Soon Hendromartono discovered she had a flair for designing exquisitely beaded bags herself, so she named Senn as her CFO, and Inge Christopher was born. Choose from a full line of beaded bags, accessory cases, and evening totes in their luxury lifestyle collection.

Top left: A ready identifier (but difficult to find): an original Whiting & Davis box. This "Mesh-Mates" box held the coin purse with key and chain shown. $20-30.

Top right: In 1999, the Whiting & Davis brand name was licensed to innovative accessories house Inge Christopher. In the words of company president and designer Inge Hendromartono, "by acquiring this brand, we are able to round out our product offering, since metal mesh evening bags are a category unto themselves. We'll maintain the quality Whiting & Davis is known for, but also add updated styles to attract a younger customer." Shown is a beaded and tasseled Inge Christopher bag, as featured in the February, 2001 issue of *Channels*.

More recent Whiting & Davis boxes, plus a display stand, $75-100.

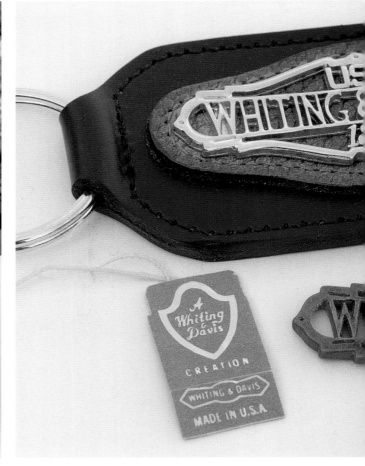

Various incarnations of the W & D logos. The key chain, $10-15.

handcrafting. While the production steps are many, here are the basics:

* High speed presses "punch out" millions of tiny metal tiles and rings daily.

* These pieces are individually knit into "stockings" of mesh fabric.

* The stockings are hand-split, cut, and sized.

* Hand spiraling conncects the bag frame to the mesh with fine coils of wire.

* Linings and finished mesh shells are sewn together by hand.

Although automation was key to the company's success, the human touch was never forgotten. As noted in a promotional brochure, "at Whiting & Davis, skilled craftspeople perform more than 24 hand operations in the finishing of a handbag or accessory."

Radiant Ring Mesh

There are two basic types of mesh handbags: ring mesh and and armor mesh . Other descriptive terms—and there are many— merely refer to varied treatments or stylings of the basic mesh used.

The earliest Whiting & Davis mesh bags were of ring mesh, consisting of rings, often of gold or sterling wire, interlinked and woven into the desired consistency. *Soldered ring mesh* was the most expensive, with each link individually soldered, the mesh then heated so that the solder would melt and

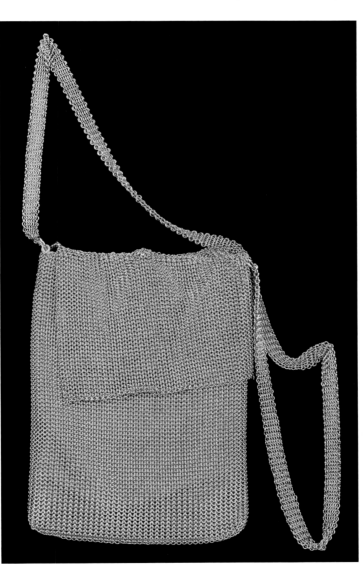

Revisiting the past: silver metal "chain mail" style ring mesh shoulder bag by Leo Narducci for Whiting & Davis. $300-400.

flow. A soldered *Princess Mary* flap bag sold wholesale in 1922 for $42; unsoldered, the bag was just over $12. In addition to their extremely fine spun texture, Whiting & Davis soldered mesh bags were promoted as "the strongest and most durable produced."

Baby Ring Mesh was an extremely fine ring mesh, as was the German-developed *Dresden Mesh*. Dresden, with its soft-edged stenciled designs on finely-woven mesh, was a marked exception to the coarser, monochromatic ring mesh turned out by other European manufacturers of the time. Fine Whiting & Davis Dresden ring mesh was truly, as the ads dubbed it "dainty gossamer."

Today, ring mesh serves a less glamorous, but equally important role as the foundation of the Whiting & Davis line of safety equipment, which ranges from aprons and armguards to reversible gloves and full-body tunics. They provide, as company literature proudly states, "your vital link to safety." The suitability of W & D ring mesh for a myriad of industrial uses, however, is a matter of long standing. As far back as the 1933 Chicago World's Fair, a Whiting & Davis exhibit brochure listed some of the many non-fashion uses for ring mesh. Among them, "motion picture screens, theatrical effects, fireplace screens, mudguard flaps, radiator covers, lamp shade trimmings and drinking glasses." (Less well publicized were some of ring mesh's more mundane applications, including "radiation protective shields, condom test nets, and rat guards.")

Amazing Armor Mesh

Despite its silken texture, ring mesh also had limitations. Color was dependent the metal used, and even with different frame treatments, one wardrobe could only accommodate so many silver and golden bags. (One exception: *Sunset Mesh.* Here, alternating ring mesh strips were plated in gold, silver, bronze, brass, and other colored metals, providing visual variety).

Armor Mesh, however, could be enameled in a much wider spectrum of vibrant colors, and decorated with figural depictions, scenic art, or, since the introduction of enamel mesh coincided with the Roaring '20s, jazzy Art Deco abstracts.

Also referred to as *enamel mesh, flat mesh, enameled costume bag mesh*, or any varied combination of the terms, armor mesh employed a different construction than ring mesh. Flat, four-armed mesh cells, or "spiders," were linked by rings at each corner, forming a flat surface, on which the design was enameled. The use of smaller spiders (about half the standard size) resulted in *Baby Flat Mesh*, which appears frequently on bags produced by Mandalian Manufacturing Company. Baby Flat Mesh had greater pliancy and smoothness than traditional armor mesh, and prices reflected this; a Mandalian bag was often double the price of a standard armor mesh bag. (A ready identifier for an unmarked Mandalian is often found in the armor mesh itself. Mandalian mesh cells are almost always set on the diagonal; Whiting & Davis armor mesh cells are more commonly—although exceptions abound—set horizontally and vertically.)

Beadlite was a popular treatment of armor mesh. To create the appearance of a beaded bag, a raised dot in the center of each spider was enameled, resulting in a completed design with greater dimensionality than possible on flat mesh. Other armor mesh treatments included *Fishscale* and Mandalian's similar *Lustro-Pearl*, in which the mesh was coated with a shiny glaze, creating the appearance of. . .well, pearls and fish scales. A variety of other descriptive terms applied to armor mesh—*bubble, round, baguette, shell, pearlized*, and *ivorytone*—are simply as billed: different (and hope-

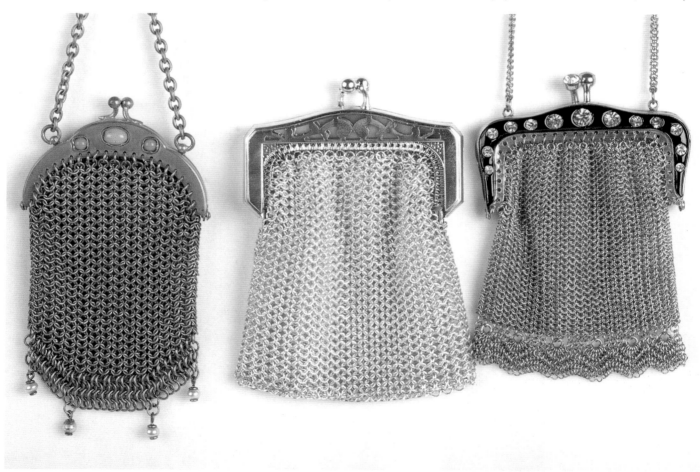

Ring mesh: three miniature purses, the outer two with jewel-studded frames. $175-225; $150-200; $175-225.

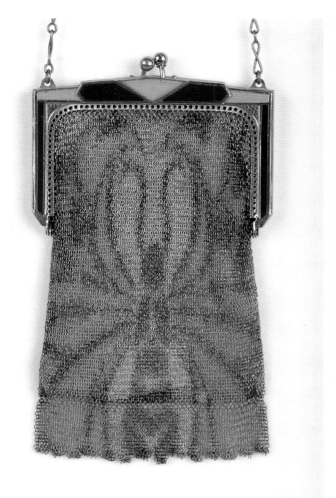

Dresden mesh: a reflected abstract flower in greens high-lights this example of fine ring mesh. The frame is accented with green enamel. $250-300.

Dresden detail.

fully, buyer-enticing) treatments and stylings of the basic armor mesh.

Enameled armor mesh fell out of fashion just prior to World War II, with solid silvertone and goldtone armor mesh bags becoming the preferred choices. The Whiting & Davis armor mesh bags of today also favor solids, or patterning that suggests natural fabrics. "Spiders" are generally larger and frames simpler, but the commitment to quality remains constant.

Metallica

Early soldered ring mesh bags were fashioned of the most expensive metals—gold and sterling silver—and were priced accordingly. With the on-set of mass production it became possible (and ad-visable) for Whiting & Davis to also offer bags made of less costly materials. Among the various metals utilized by mesh manufacturers over the years have been silver plate, gold plate, platinum plate, gun-metal, brass, nickel-plated brass, copper, and vermeil (gold plate over sterling silver). During the

1930s, aluminum also raised its shiny head as a metals option under the name *Alu-Mesh*. Another inexpensive choice, popular with many manufac-turers and buyers, although unused by W & D, was nickel (German) silver.

Metal variety brought the mesh bag within the reach of every budget—but for those without bud-get restraints, there were always more exotic possi-bilities. In 1910, a fashion magazine grumbled "one can pay $25,000 for a jewel-studded solid gold mesh bag, if one has the money, and wants to burn it that way." Leaping ahead to 1990, the money-burners still had something to drool over: Anthony Ferrara's $532,000 gown of 18-karat gold Whiting & Davis mesh, created for an Absolut Vodka promotional campaign. It was also available in sterling silver—a steal at just $100,000. Although Whiting & Davis ads promised "you can give so much for so little," chances are this isn't the item they were talking about!

Scarcely any creation of the jeweler's craft is dearer to the feminine heart than a bit of gleaming gold or silver Whiting & Davis mesh.
Whiting & Davis ad, circa 1923

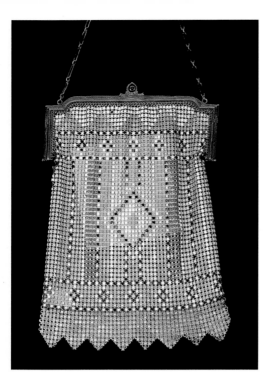

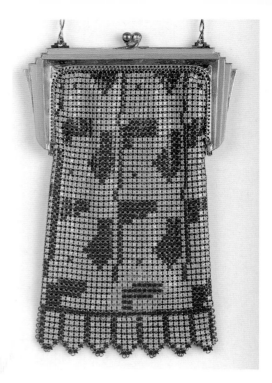

Left: Enamel flat armor mesh: Art Deco pastel stripe-and-diamond pattern, vandyke ("half-diamond") skirt. $150-200.

Right: Another enameled armor mesh bag, this in mint green, with a pink and brown random geometric pattern. The frame detailing is mint green and blue enamel. $150-200.

Detail, enameled flat armor mesh.

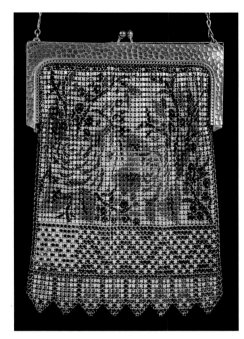

Enameled armor mesh was also an ideal canvas for more realistic scenes, such as this vivid arrangement of yellow flowers. The frame is hammered gold metal. $200-250.

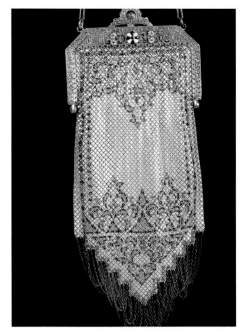

Mandalian: the use of fine or "baby" armor mesh was a Mandalian hallmark. Turquoise and orange on silver, "V" base with looped silver fringe. $375-425.

Floral detail.

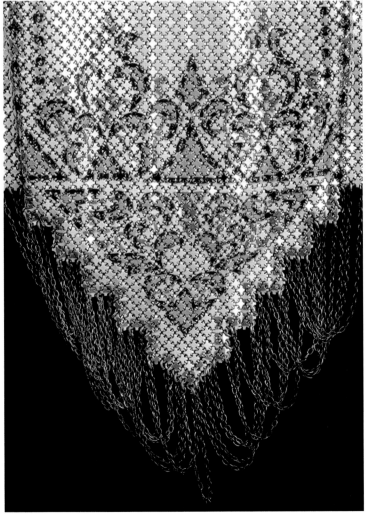

Detail, Mandalian mesh and fringe.

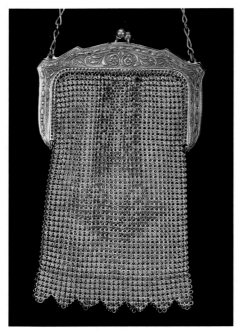

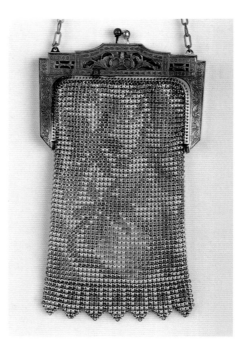

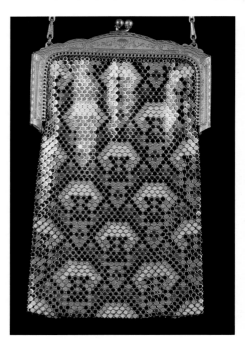

Beadlite: raised enameled dots simulate the appearance of beading on armor mesh. Here, the "beads" are pink, orange, and green. $125-175.

Beadlite back-to nature: festive flowers on a silvery background. $150-200.

Although "ring" and "armor" are specific mesh types, terms such as "round mesh", "beadlite", and "bubble mesh" refer to variances in the shape, finish, size, or treatment of the basic mesh. Shown, a round mesh bag with a pattern of hexagons in rich jewel tones. $225-275.

Beadlite detail.

Round mesh detail.

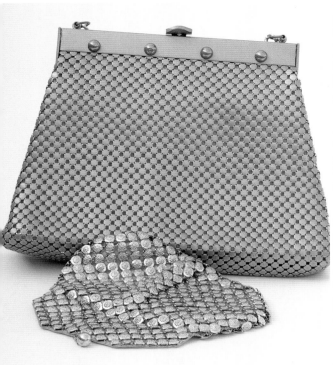

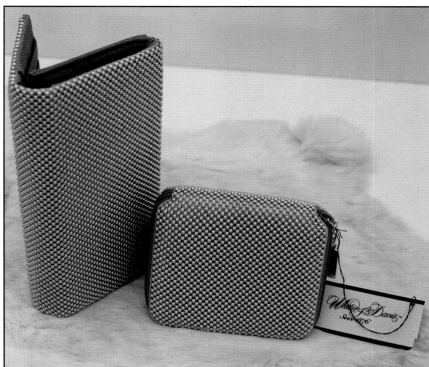

Gilding the lily: the bag in back is of traditional armor mesh. On the change purse in front, shell patterns have been embossed on the mesh. $15-25; $30-50.

Recent "bubble mesh" wallets, $30-40 each.

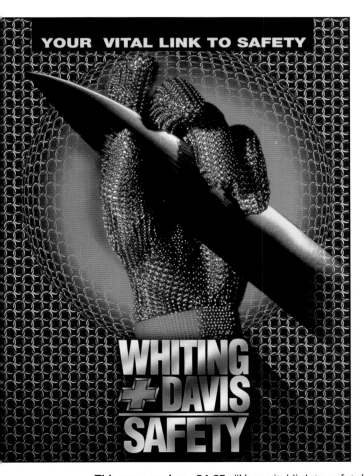

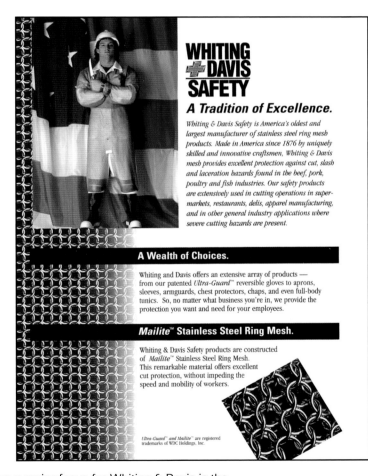

This page and pp. 34-35: "Your vital link to safety". Today, a major focus for Whiting & Davis is the production of stainless steel ring mesh protective gear. This brochure illustrates the wide assortment of W & D safety garments available, and their uses in industries ranging from food processing to law enforcement.

Easy-to-Size, Color-Coded Products.

Whiting & Davis provides a color-coded Glove Size chart to make choosing the right glove size quick and easy. For easy identification, the glove strap colors on Whiting & Davis Safety gloves correspond to the colors on the Glove Size chart. Sizes for sleeves, tunics and sleeves with mesh T-shirts also correspond to these colors.

Reversible Safety Gloves to Fit Either Hand.

Most Whiting & Davis Safety gloves, while packaged to fit the left hand, are easily reversible, using a simple "3-Step" method, to fit either hand, thus reducing the need to carry an inventory of gloves in both left and right hand styles.

Strong, Comfortable and Easy to Clean.

Because of their *Mailite™* construction, Whiting & Davis Safety products are not only strong, durable and lightweight, but also extremely sanitary. They resist process fats and oils and a quick cleaning in soap and hot water is all that's required to eliminate potentially harmful bacteria.

Standard and Optional Glove Closures.

STANDARD ADJUSTABLE BUCKLE
Each glove comes equipped with a standard adjustable buckle strap, unless otherwise specified *(standard and non-reversible)*.

QUICK RELEASE STRAP
Convenient Velcro® closure *(optional and non-reversible)*.

DOME FASTENER
Snap-type closure. Quick and easy to remove. Adjustable to all wrist sizes *(optional and reversible)*.

PALM STRAP
Ensures firm fit for thumb and two finger glove, while providing maximum mobility. Available in Standard Buckle, Velcro® or Reversible Dome Fastener *(optional)*.

Comprehensive Repair Service.

Whiting and Davis Safety offers a complete repair program. All repairs are performed by our skilled "repair specialists" and include the replacement of straps and missing, broken or damaged rings. All repaired products undergo thorough quality control before being sanitized, individually packaged and returned to you in "like-new" condition.

Custom Design to Fit Your Needs.

We offer a "Custom-Made" service to accommodate unusually small or large sizes, or other special requirements. And we routinely conduct on-site plant surveys to assess potentially hazardous applications and to offer effective solutions. If we don't have the exact *Mailite™ Stainless Steel Ring Mesh* item you need, we'll design and manufacture it to meet your specific requirements.

International Distribution Network.

Whiting & Davis Safety maintains an international network of stocking and servicing distributors. For the name of your local distributor or for additional information, just call us.

WHITING + DAVIS SAFETY

WHITING & DAVIS SAFETY
a division of WDC Holdings, Inc.
P.O.Box 1270 • 200 John Dietsch Boulevard
Attleboro Falls, MA 02763
800-876-MESH (6374)
Tel (508) 699-4412 • Fax (508) 643-9303

Ultra-Guard™ and Mailite™ are registered trademarks of WDC Holdings, Inc.

WHITING + DAVIS SAFETY

Gloves

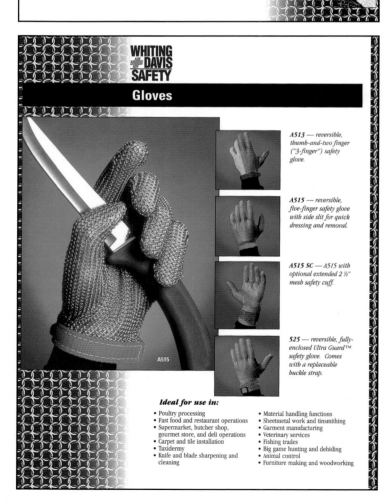

A515

A513 — reversible, thumb-and-two finger ("3-finger") safety glove.

A515 — reversible, five-finger safety glove with side slit for quick dressing and removal.

A515 SC — A515 with optional extended 2 ½" mesh safety cuff.

525 — reversible, fully-enclosed Ultra Guard™ safety glove. Comes with a replaceable buckle strap.

Ideal for use in:

- Poultry processing
- Fast food and restaurant operations
- Supermarket, butcher shop, gourmet store, and deli operations
- Carpet and tile installation
- Taxidermy
- Knife and blade sharpening and cleaning
- Material handling functions
- Sheetmetal work and tinsmithing
- Garment manufacturing
- Veterinary services
- Fishing trades
- Big game hunting and dehiding
- Animal control
- Furniture making and woodworking

WHITING + DAVIS SAFETY

Gloves

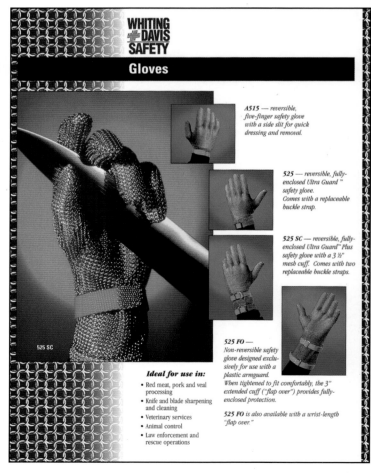

525 SC

A515 — reversible, five-finger safety glove with a side slit for quick dressing and removal.

525 — reversible, fully-enclosed Ultra Guard™ safety glove. Comes with a replaceable buckle strap.

525 SC — reversible, fully-enclosed Ultra Guard™ Plus safety glove with a 3 ½" mesh cuff. Comes with two replaceable buckle straps.

525 FO — Non-reversible safety glove designed exclusively for use with a plastic armguard. When tightened to fit comfortably, the 3" extended cuff ("flap over") provides fully-enclosed protection.

525 FO is also available with a wrist-length "flap over."

Ideal for use in:

- Red meat, pork and veal processing
- Knife and blade sharpening and cleaning
- Veterinary services
- Animal control
- Law enforcement and rescue operations

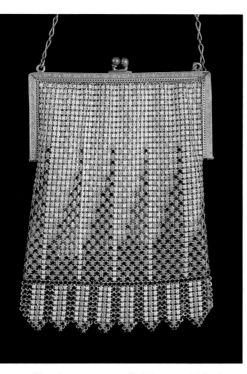

Checkers, anyone? Blue-and-black-checkered tree shapes against a gold-and-white-checkered background. $200-250.

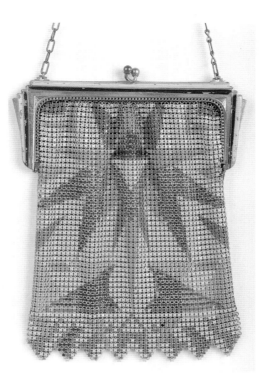

A lively sunburst in coral, green, and blue, with green repeated in the enameled frame. $200-250.

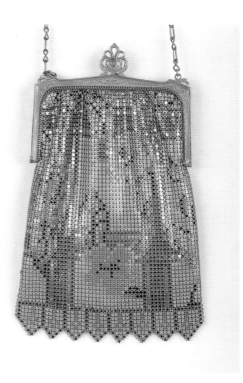

An evening dazzler: shiny gold, with subtle black accents. $200-250.

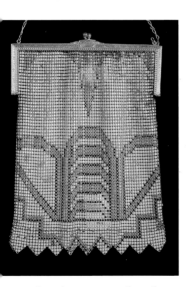

An abstract escalator? Soft blues suggest the pattern on off-white. $200-250.

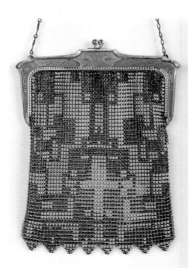

Domino-esque: black and white beadlite. $125-175.

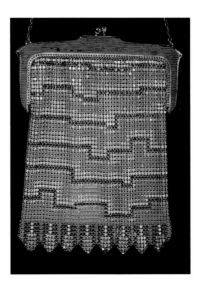

Horizontal stepped lines in green and silver, reminiscent of cityscape silhouettes, on green. $150-200.

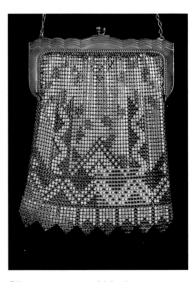

Silver, green, and black lines echo the shape of the vandyke skirt. A repeating pattern is also seen in the four-tier scalloped frame. $200-250.

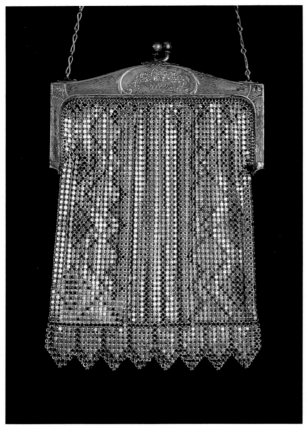

Metallic "rickrack" in black and coral on silver. $150-200.

Rickrack detail.

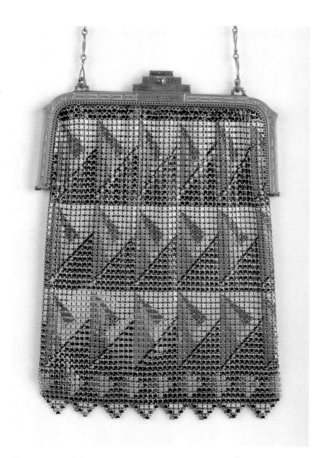

Greens, golds, and browns, in a series of repeating triangles. $200-250.

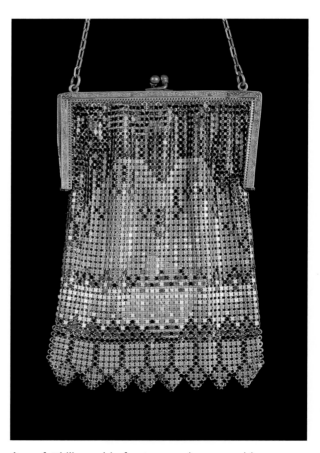

A confetti-like swirl of autumn colors on gold. $150-200.

40

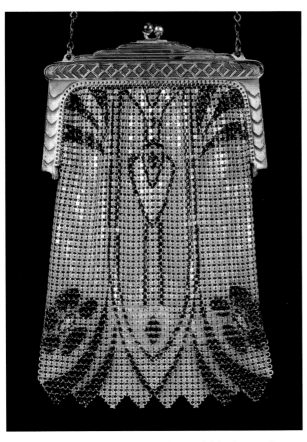

Shield motif in robin's-egg blue and black, on silver.
$200-250.

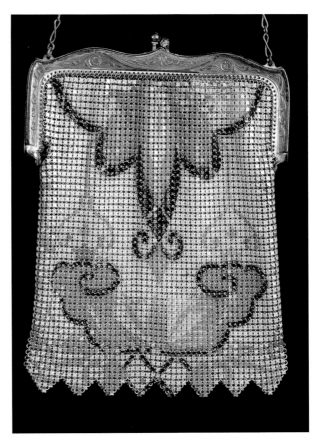

Multicolor central pendant, outlined in heavy black.
$200-250.

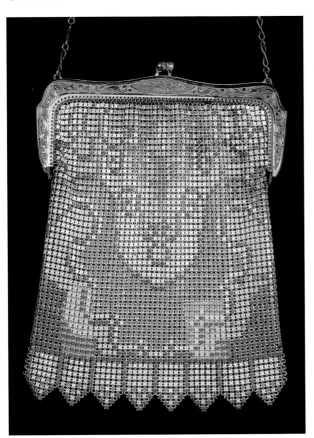

Delicate arabesque pattern in muted greens, browns,
and tans. $150-200.

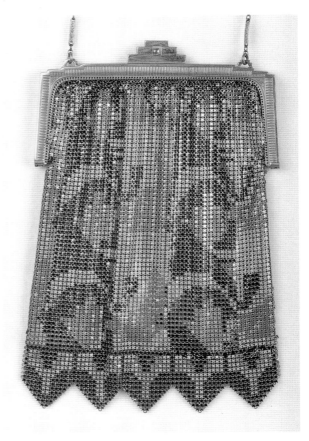

Dangerous curves: green and purple curved abstract
on gold. $150-200.

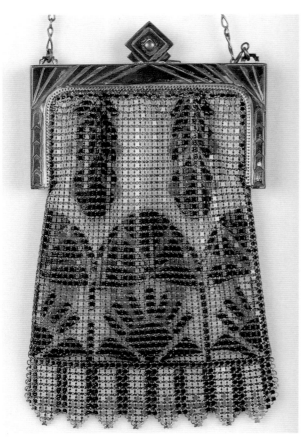

The suns rise, the vines hang, repeatedly in pink and black. $150-200.

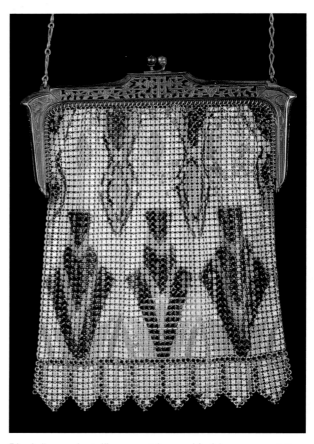

Black "arrowhead" vases, trimmed in blue, on a white background. $200-250.

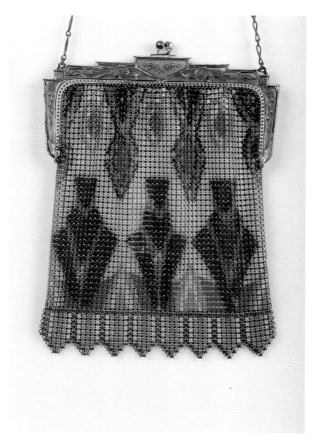

The same arrowhead design, here in blue and orange. $200-250.

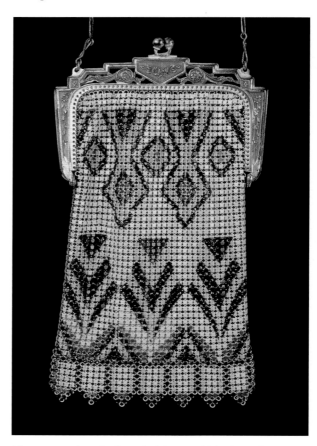

More arrowheads, in pale blue and black against pale yellow. $200-250.

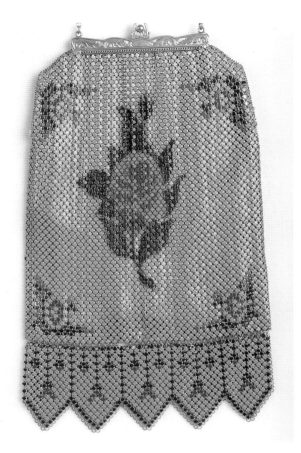

A single pink rose on a muted green background.
$200-250.

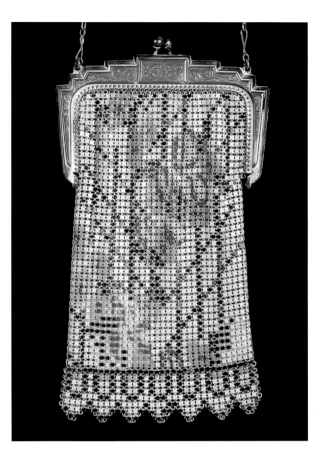

Down the garden path: pink and orange flowers
climb a black trellis. $250-300.

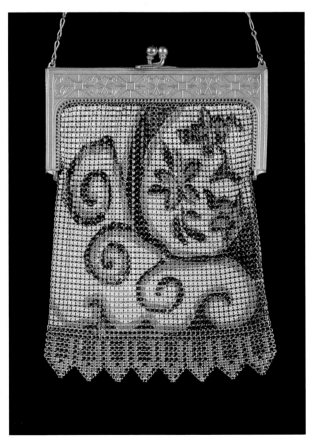

Orange flowers on white, surrounded by black and
gold spirals. $200-250.

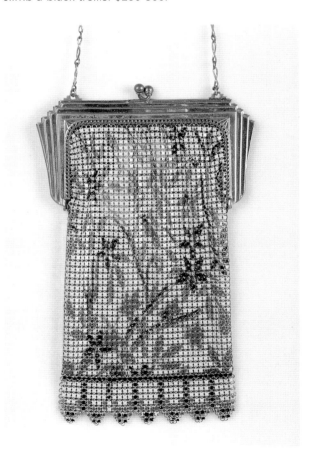

Spring parade: green stems, with starflowers of red
and darker green, stepped gold frame. $250-300.

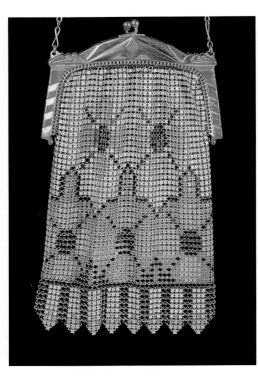

The angles create the flowers in this formal pastel arrangement. $200-250.

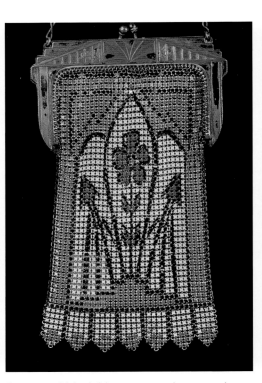

Green and black blossoms under a coral arch. The design on the metal frame suggests a bridge. $200-250.

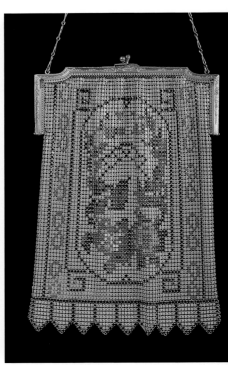

In a country garden: colorful, old-fashioned nosegay, framed in an oval. $250-300.

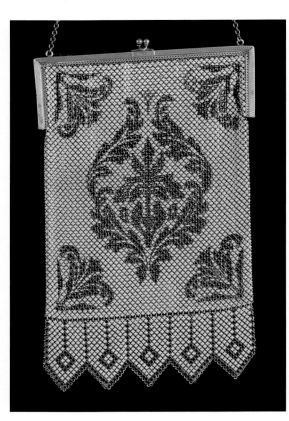

Austere black floral spray on ivory. $150-200.

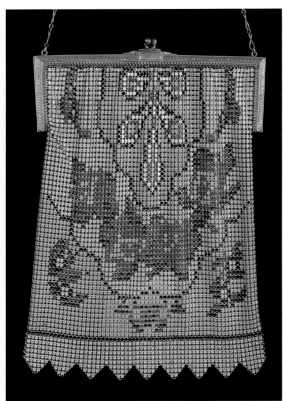

Victorian pink posies on a background of yellow and light blue. $200-250.

Posy detail.

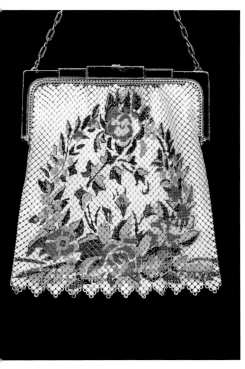

Wreathed in color: an elaborate, multi-color floral spray on white. $250-300.

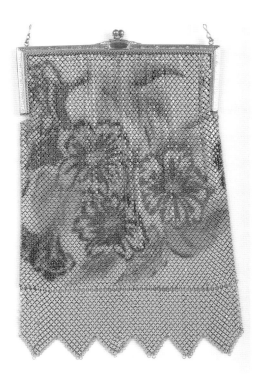

Polychrome petals on green. $150-200.

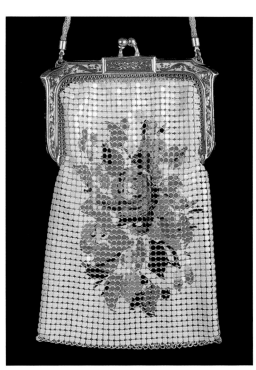

The look of needlework in mesh: a bright bouquet, centered on a beige background. $150-200.

Bouquet detail.

Detail, Japanese garden.

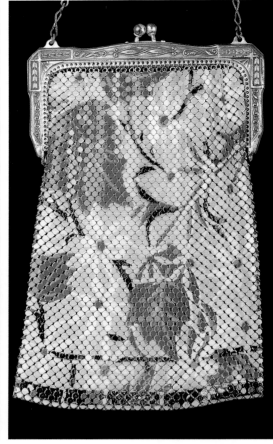

The entire Japanese garden: delicate yellow and white flowerets on slender green stems, set against a peach-pink background. $200-250.

Floral detail.

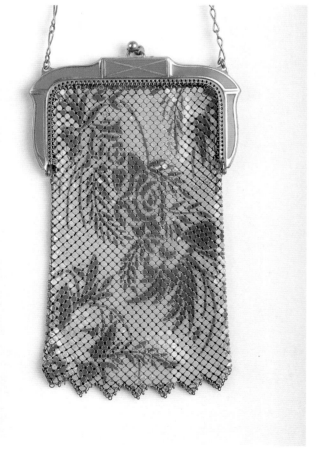

The full artistic floral rendering, hot colors on ivory, accented by green and blue enameled frame. $200-250.

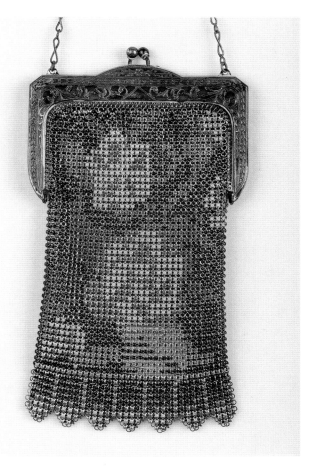

Beadlite blossoms, in red and white on green. $125-175.

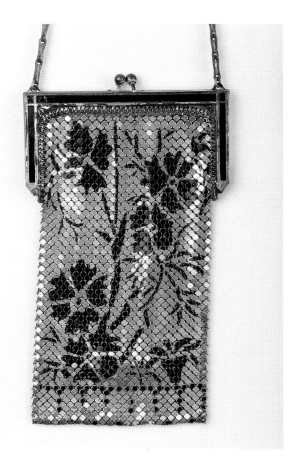

Black blooms on shiny silver, black enameled frame. $200-250.

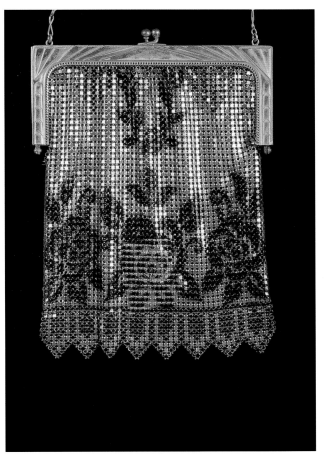

At dawning: black floral outlines silhouetted against a gold mesh sky. $150-200.

Detail, black blooms.

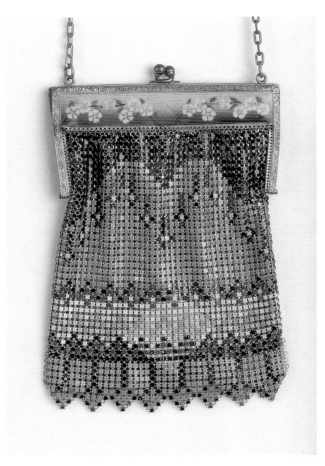

Hardy perennials: a garland of tiny white florets on the mesh bag, and a parade of enameled white flowers across the bag frame. $275-325.

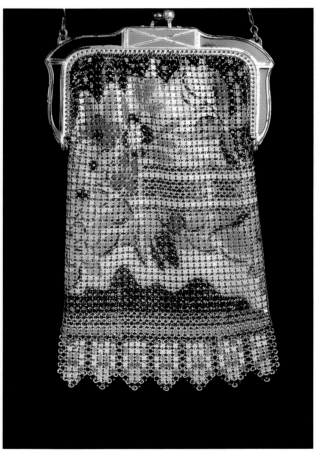

Above: Floral overhang detail.

Left: Forced perspective creates an illusion of shadowy mountains glimpsed through an over-hang of oversize coral and red flowers. $200-250.

The Dresden touch: fine ring mesh and oversize pink flowers combine for a unique watercolor effect. $250-300.

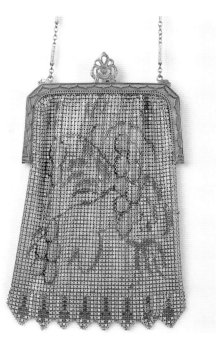

Good enough to eat: lavender grapes, with orange accents. $150-200.

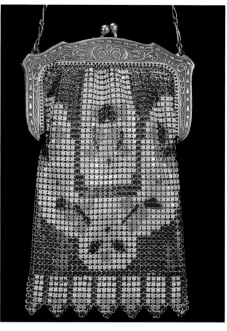

Life is just a bowl of cherries: fresh fruits, ripe for the picking. $200-250.

Dresden detail.

Go Figure

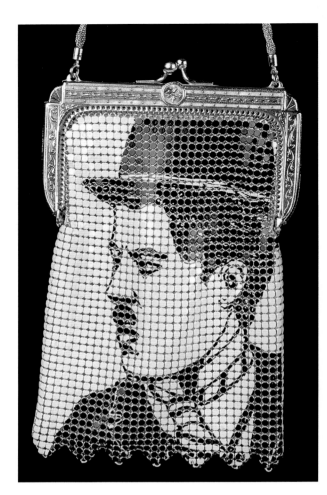

Clap hands, here comes Charlie! Charlie Chaplin bag, issued as part of the Whiting & Davis "Star Series" in 1976, celebrating the company's 100th anniversary. Four film stars were featured; Chaplin, in recognition of his career in silent films, was the only one in black and white. $1300-1500.

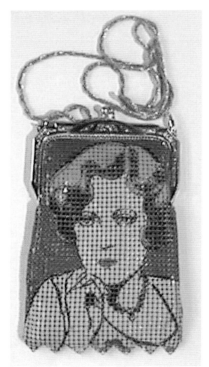

Warm good humor and even warmer good looks made Marion Davies a hit with 1930s screen audiences—as well as with publisher William Randolph Hearst. $2000-2200.

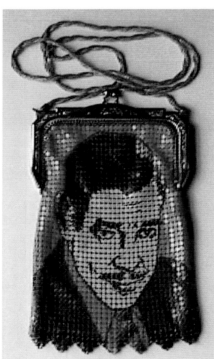

The King of Hollywood: Clark Gable's rugged handsomeness immortalized in the "Star Series". $2000-2200.

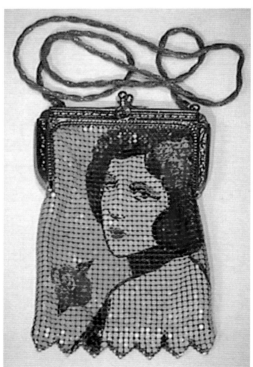

Rarest of the rare: "Star Series" bag celebrating exotic silent screen beauty Reneè Adoreè. Once legendary, now long-forgotten, Adoreè lit up the screen throughout the 1920s, before succumbing to tuberculosis at the height of her career. $2200-2400.

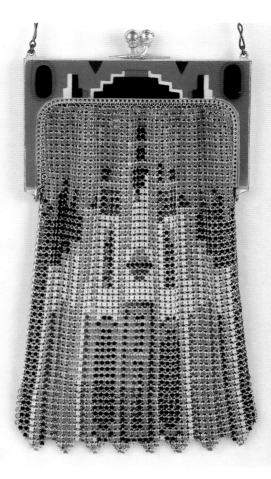

Top left: A skyline, Dresden-style: shadowy building outlines seen through a blue mist. $200-250.

Top right: City lights: abstract city skyline against hot orange sky. The big-city theme is repeated on the enamel frame. $400-450.

Bottom: Frame detail.

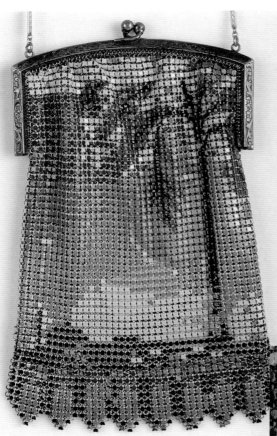

Island magic: inviting tropical scene, with sun, palm tree, and clouds. $400-450.

Island detail.

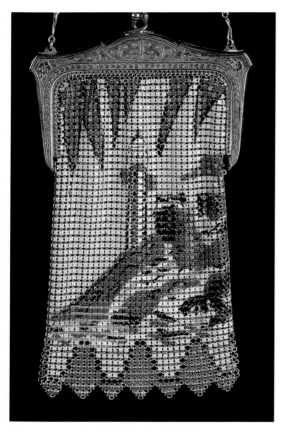

Ahoy there! Lighthouse on cliff, in shades of green. $350-400.

Feathers & Flames

A feathery swirl in hot pink, orange, chartreuse, and black. $200-250.

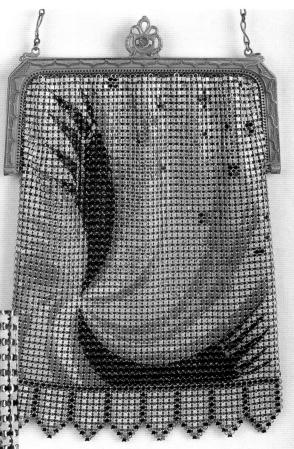

Feather detail.

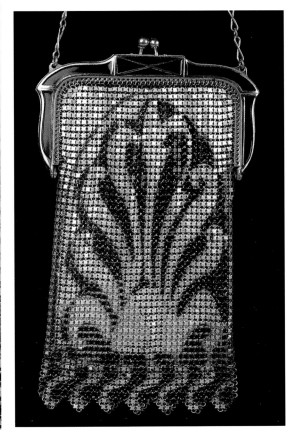

Black plume on silver, black enamel frame. $200-250.

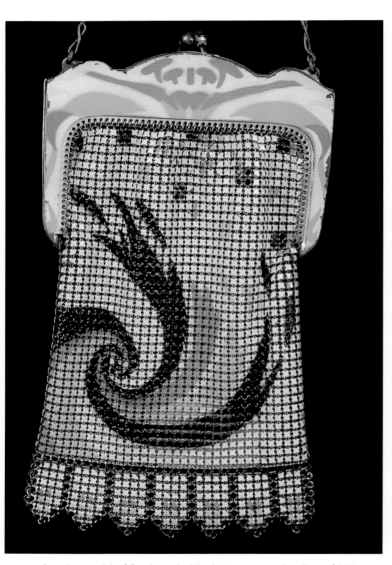

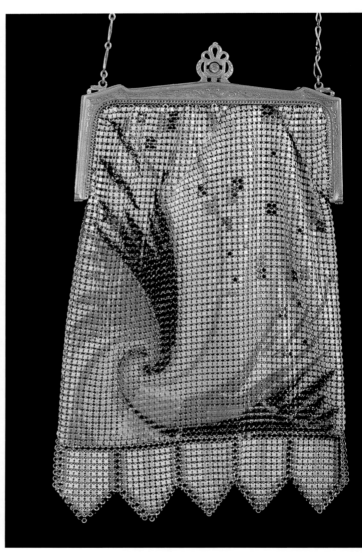

Another swirl of feathers in black, orange and yellow. $225-275.

A similar feather pattern. $200-250

Chapter 5
A MIGHTY FINE MESH
Dazzling Dresden

There's something new in the air! The return of the ultra-feminine to Fashion makes the Dresden Mesh Costume Bag a style necessity.
Ladies' Home Journal
November, 1930

The "ultra-feminine" watercolor-like Dresden mesh may not initially appeal to every taste. Once experienced, however, these dreamy pastel designs on velvety-fine ring mesh prove irresistible.

Dresden mesh was developed by the German firm of Dresden and Weiss, based on patents provided by A.C. Pratt, inventor of the automatic mesh-making machine. Prior to World War I, Mr. Dresden moved to England, and was a founder of the British Automatic Mesh Company. Whiting & Davis, citing Pratt's

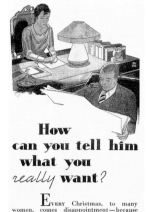

copyright assignments, claimed copyright infringement. In 1918 an agreement was reached, and the Dresden machines were brought to the United States. Whiting & Davis assumed manufacture of all Dresden mesh, with the exception of a small operation licensed in Paris, which continued into the mid-1920s. The terms "Dresden" or "Baby Ring Mesh," eventually became synonymous with any extremely fine ring mesh, not only that manufactured by Whiting & Davis.

Beautiful Dreamers

Dresden mesh bags are most readily identified by their gauzy, soft-edged artwork, primarily indistinct abstract patterns, as well as floral and other nature

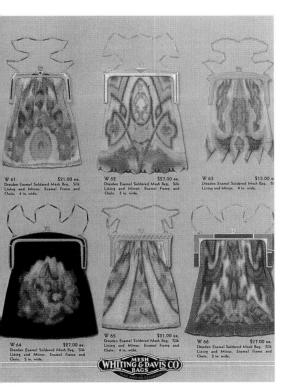

Above & far right: From 1932, two Whiting & Davis catalog pages, with an enticing assortment of Dresden enamel mesh possibilities.

"How can you tell him what you *really* want—" Well, you could always show him this ad, with its picture of a Dresden enamel soldered mesh bag, and hope he takes the hint! *Ladies' Home Journal*, November, 1930.

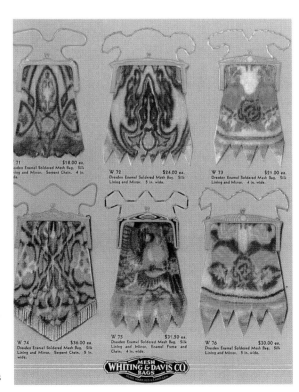

motifs. Visuals were stenciled on the ring mesh, in mellow, muted colors. The overall effect is a relaxing one, as if the image is seen through a mist. The skirts of Dresden bags sometimes aped the vandyke or stepped bases of armor mesh bags. Other treatments included ring mesh fringe, occasionally arranged in graceful scallops.

Slightly surreal, Dresden mesh bags ceased production in the 1940s, with the onset of World War II, and were never revived. Fine ring mesh was no longer made, and fashion had moved on. While it lasted, however, Dresden was definitely the stuff dreams are made of.

Here is a bag to delight all who love beautiful things. See it at your jewelers. The price is most reasonable.
Whiting & Davis advertisement, circa 1923

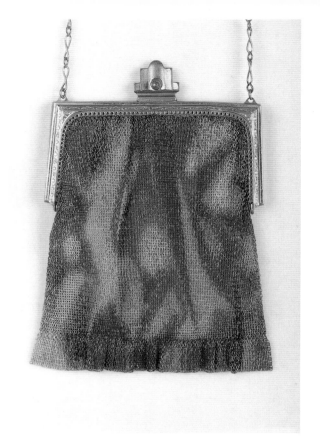

Soft reds, yellows, and blues, in an expressionistic Dresden rendering. $250-300.

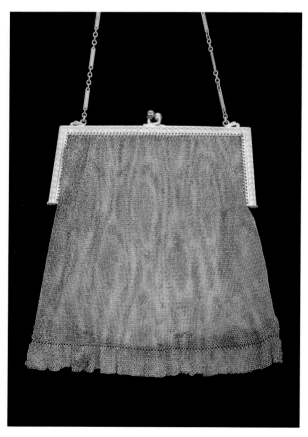

Multi-color abstract, with light magenta predominant. $200-250.

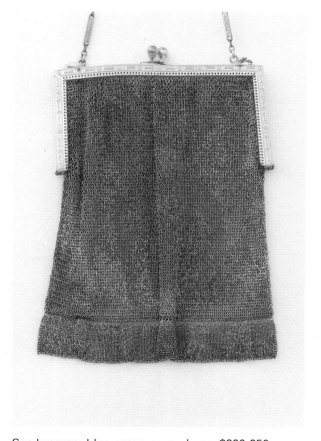

Sea breezes: blue-green ocean hues. $200-250.

Opposite page: Detail.

72

Seeing spots: black spots on white, against a gold background. $300-350.

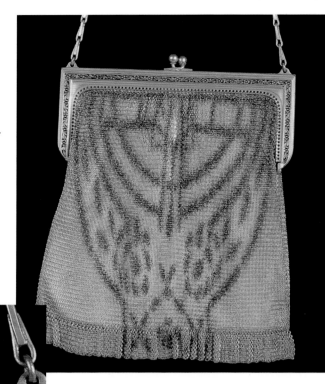

Spot on gold detail.

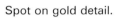

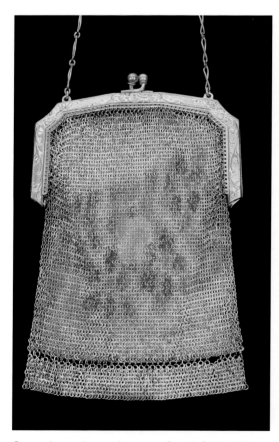

Gauzy lavender and orange floral. $200-250.

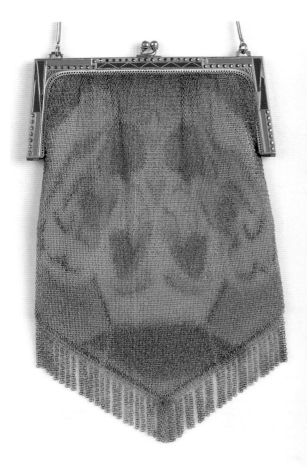

Flower basket abstract in yellow, orange, and lime. $300-350.

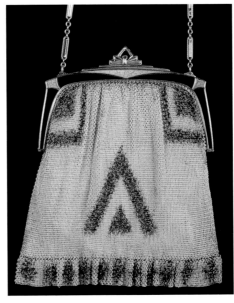

Black "teepee" on off white, black enameled frame. $200-250.

Detail, flowers and frame.

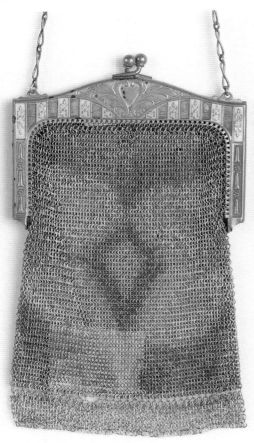

Central red diamond with blue and green border accents. $200-250.

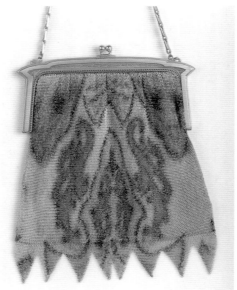

Hazy flames in orange and turquoise, vandyke skirt. $200-250.

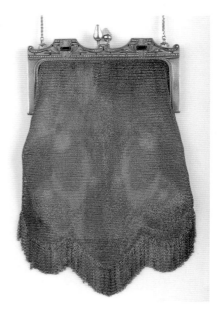

Bonbon pastels on silver, delicately curving tri-point ring mesh fringe skirt. $300-350.

Fringe detail.

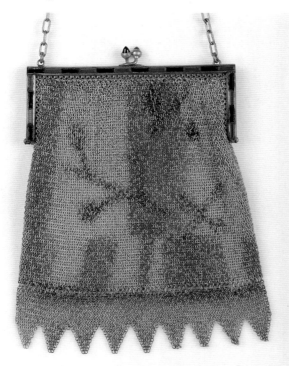

Red rectangles, and random black "x's", red and black enamel frame. $200-250.

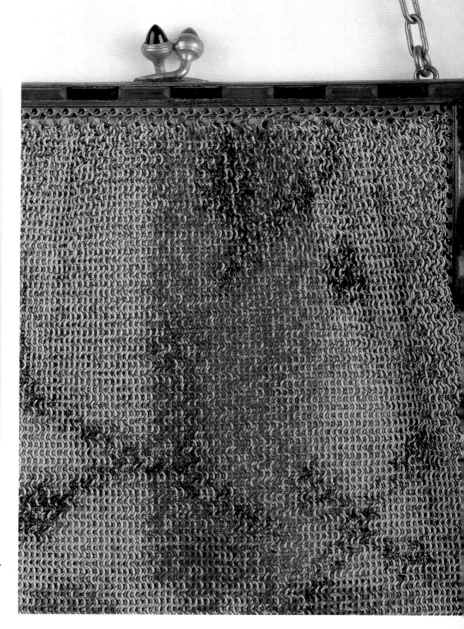

Detail.

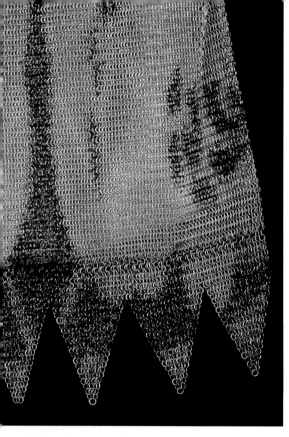

Animal print detail.

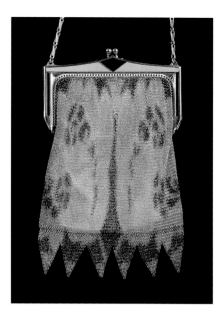

Follow the tracks: black animal prints on sky blue, blue and black enamel frame. $300-350.

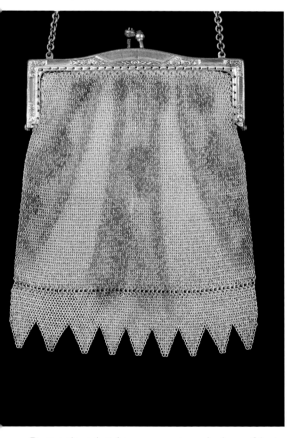

Rust-colored stripes separate splashes of hot pink, blue, and green. $250-300.

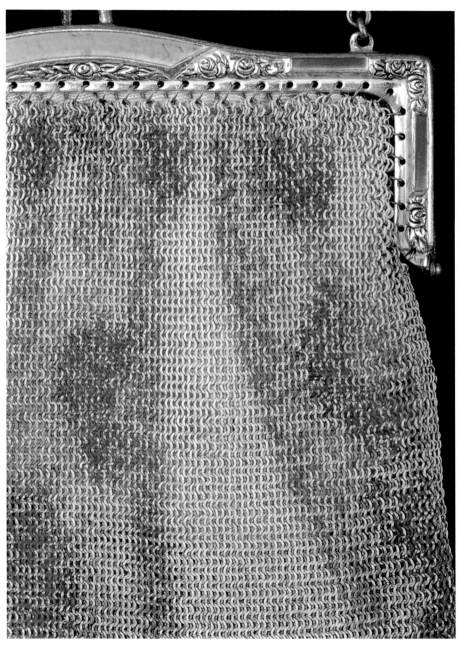

Detail, including blue and rust enameled frame.

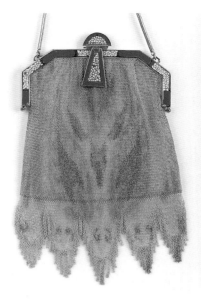

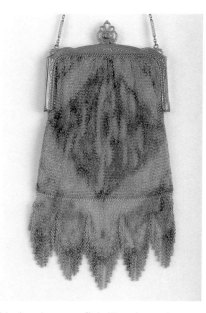

Orange and green searchlight beams cross paths on an off-white background. $200-250.

Paisley pastel in pink, blue, and green. The ornate red enameled frame is stippled with white. $300-350.

Under the sea: fish-like shape in blues and greens, scalloped ring mesh skirt. $200-250.

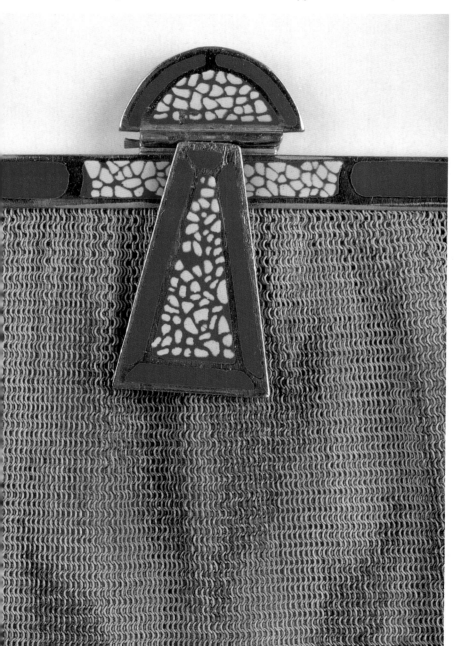

Clasp and frame detail.

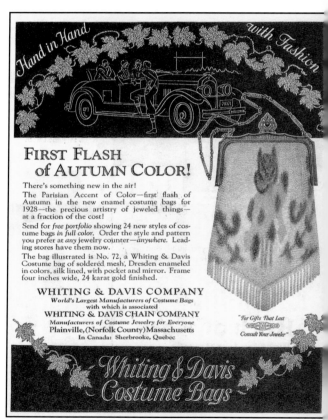

"The precious artistry of jeweled things—at a fraction of the cost": Dresden mesh from Whiting & Davis. *Ladies' Home Journal*, November, 1930.

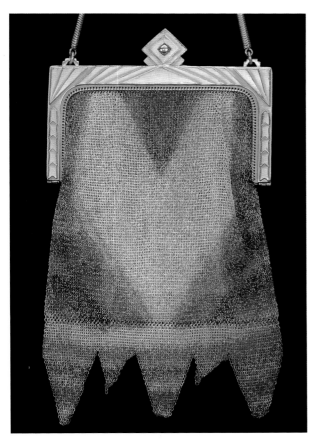

Hearts are trumps:-downy-edged central heart shape, irregular fringed skirt. $200-250.

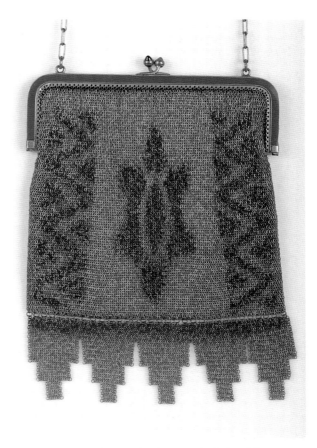

Blue on blue: soft blue background, darker blue accents, blue enameled frame. $200-250.

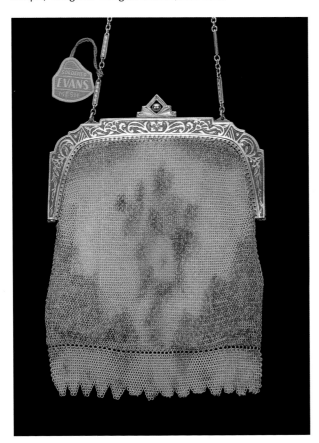

The Evans version of Dresden mesh: a cloudy floral pastel by the Evans Case Company, with tag. $175-225.

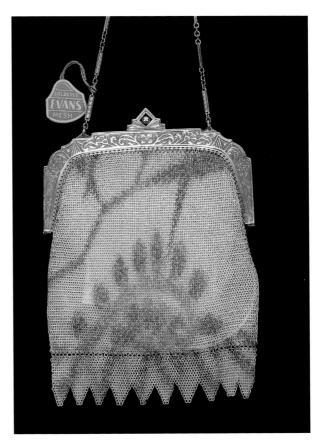

Also by Evans (and also tagged): sun peeking over the horizon. $175-225.

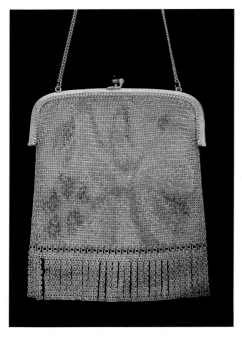

Dresden, German-style: flowering branch, and extra-long ring mesh fringe. $200-250.

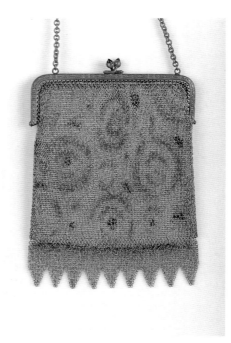

Guten tag: another Dresden from Germany, orange brush strokes on acid green. $175-225.

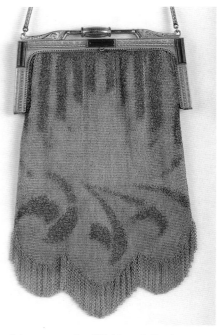

Back home again: Whiting & Davis Dresden mesh, jazz-age plumes and ribbons in misty purple and yellow, pull-bead clasp. $300-350.

Plume and fringe detail. Careful shading extends the painted shapes into the fringe.

Brush stroke detail.

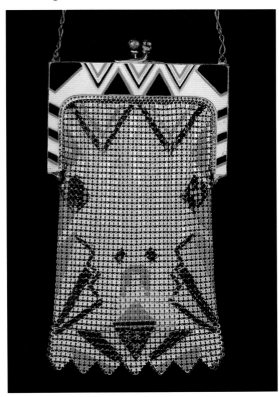

Lines and angles: black and orange rays combine with black and orange triangles on a divinely Deco enameled frame. $225-275.

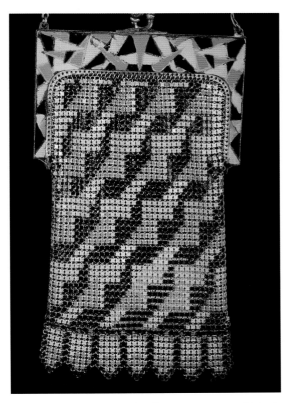

A crazy quilt combo of yellow, orange, and black enamel tops off a mesh with repeating staircase motif. $275-325.

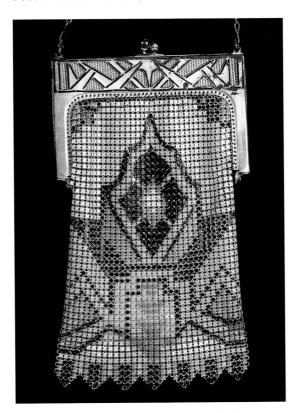

Angling crossed ray shapes are the focal point on the frame; the bag features a black, pink, and green central medallion. $225-275.

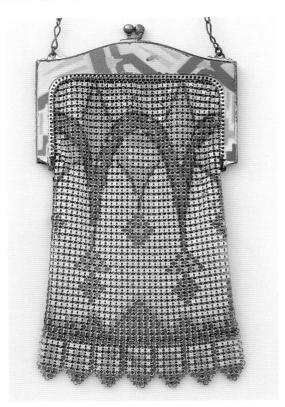

A delicate mesh pattern in pink and light blue is enhanced by random enamel shapes in the same colors on the frame. $225-275.

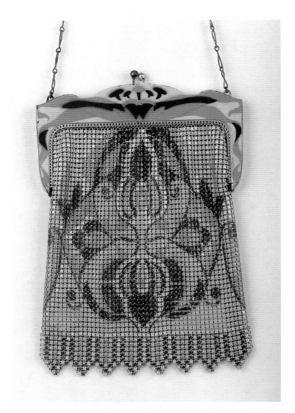

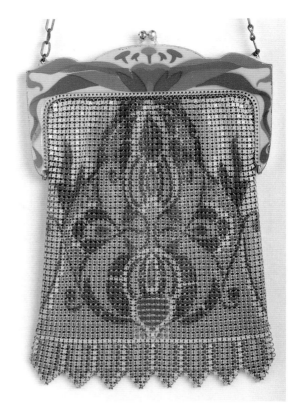

Stylized passion flower in green, yellow, and orange, with frame enameled in matching colors. $225-275.

The same bold design, here in hot pink, green, and blue. $225-275.

Detail.

Persian carpet and frame detail from bag at right.

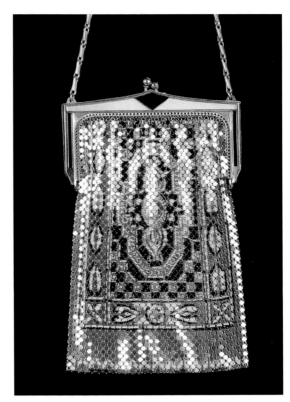

Shiny silver-and-black Persian carpet pattern, white and black enamel frame with central black diamond accent. $225-275.

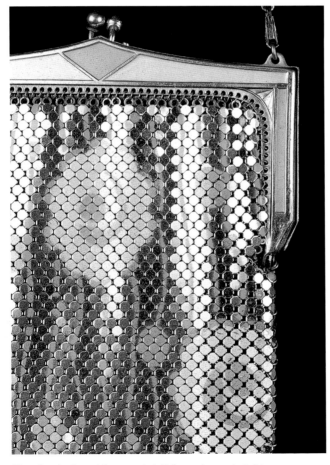

Floral spiral and frame detail from bag at right.

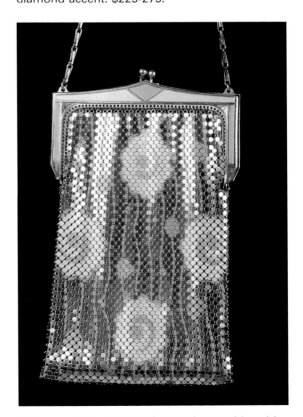

A frame similar to that shown above with gold diamond accent, white and gold floral spirals on the silver mesh. $225-275.

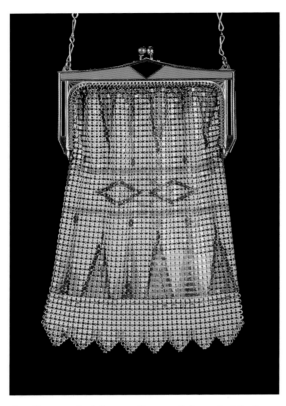

Another central frame diamond, here in black against orange. The autumnal mesh design on cream suggests Indian corn. $225-275.

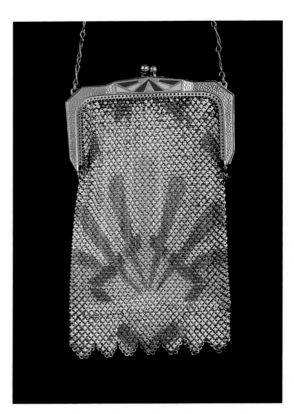

Beadlite rising sun in purple and orange, brown enamel sunrays on frame. $175-225.

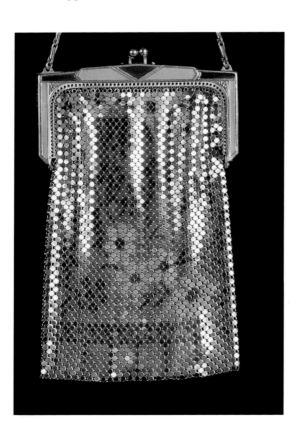

Direct from the florist: blue and gold flowers on sparkling silver, with the enameled frame picking up the blue and gold highlights. $225-275.

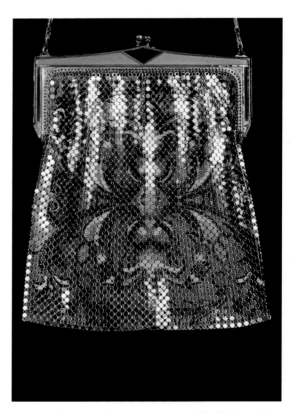

Stylized Oriental flower on a metallic field, with gold and blue enameled frame. $225-275.

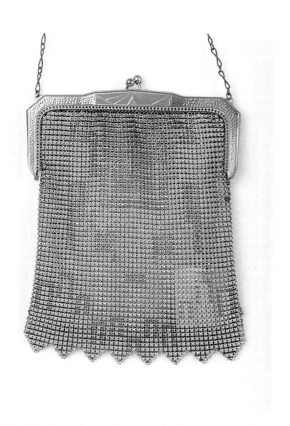

Beadlite box shapes in muted chartreuse and purple, blue enamel rays on frame. $175-225.

Blue rays and beadlite detail.

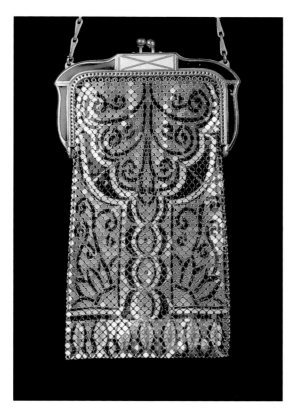

From the Far East: black and white arabesques on glitter gold, with black and white enameled frame. $275-325.

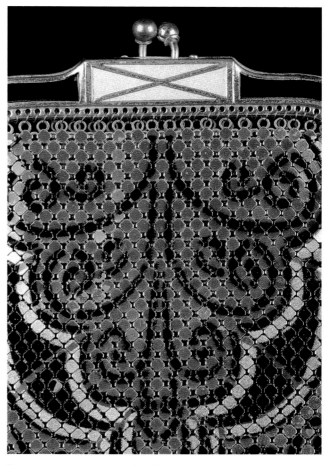

Frame and arabesque detail.

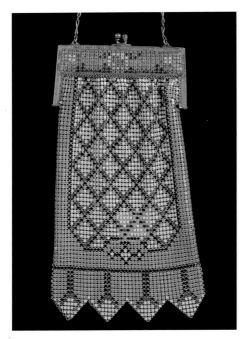

Diamond grid set on a green background, geometric red and white flowers with green leaves enameled on frame. $325-375.

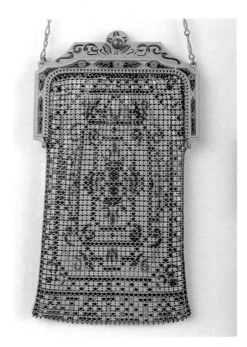

Multi-colored "magic carpet" mesh, with ornate orange and brown enameled floral motif frame. $325-375.

Magic carpet and frame detail.

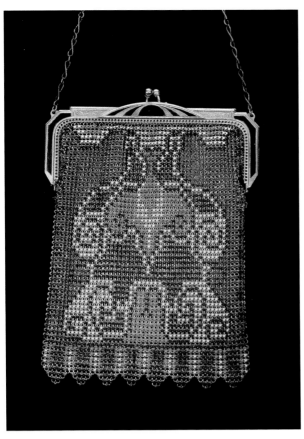

Abstract Mayan figure in muted beadlite tones, black and silver enamel dome design on frame. $225-275.

Dome detail.

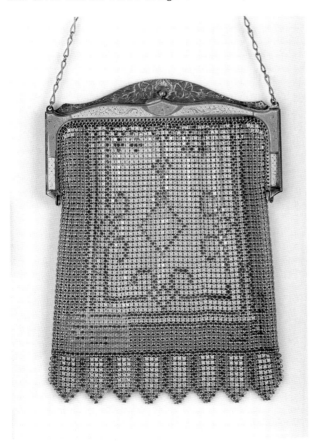

Green and white Persian rug pattern on coral, blue and white embossed enamel on frame. $225-275.

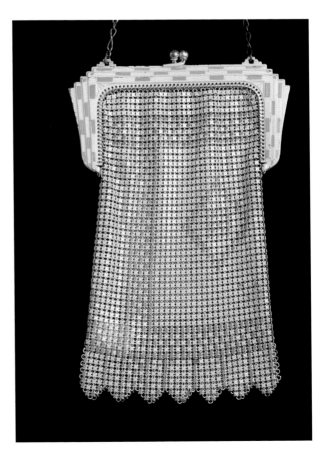

White enamel frame with hot pink bars, hot pink diamond and border strips on off-white mesh. $225-275.

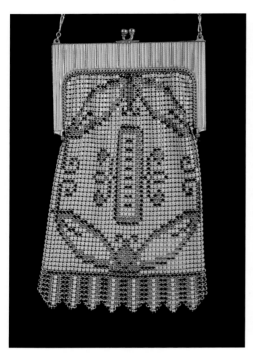

Taking wing: a butterfly and its reflection in black and orange on white. Orange and white enamel define the vertical lines on the frame. $275-325.

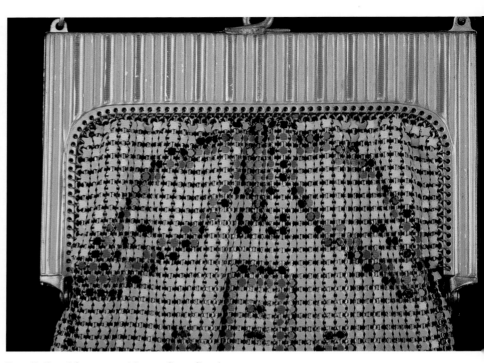

Detail, lined frame and butterfly reflection.

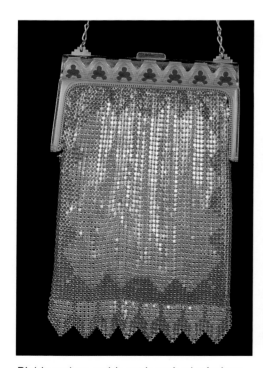

Richly red on gold: each arched window on the gold metal frame displays a red enamel cutout. $325-375.

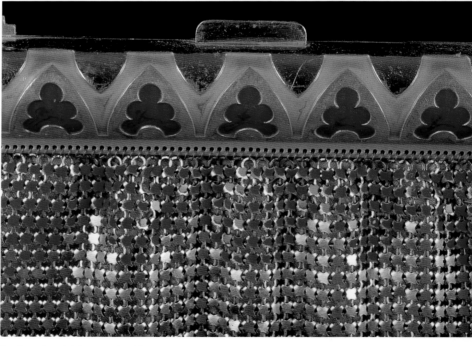

Red and gold frame detail.

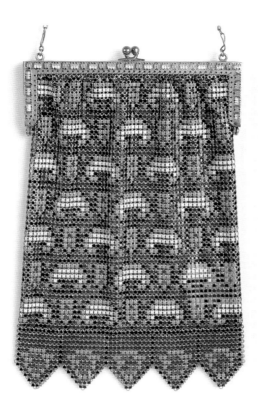

On the frame, white enameled bead shapes with blue accents. On the bag, an explosion of multi-colored confetti against gold. $325-375.

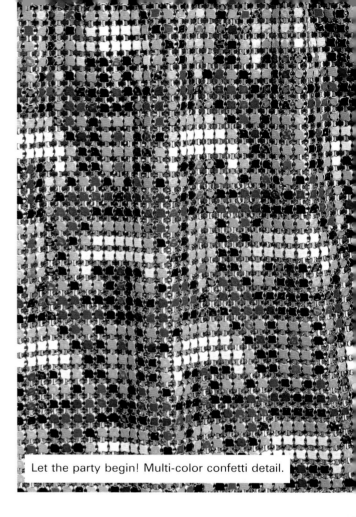

Let the party begin! Multi-color confetti detail.

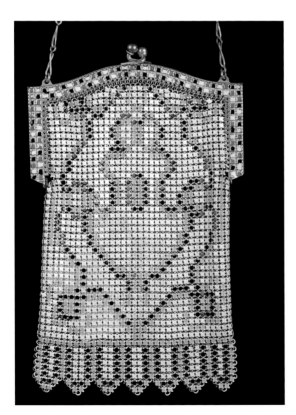

A checkered past: lime green, black, and white enameled checkerboard frame. The bag's medallion is in the same colors. $325-375.

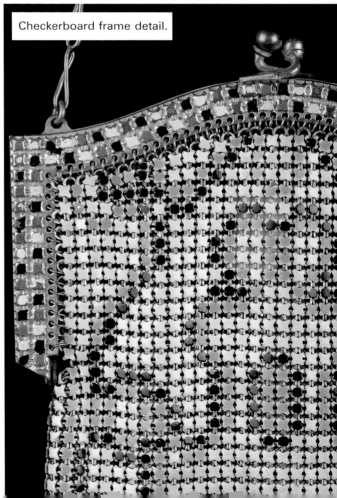

Checkerboard frame detail.

Crown Jewels

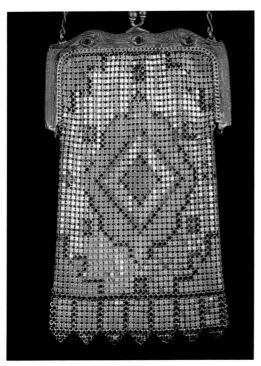

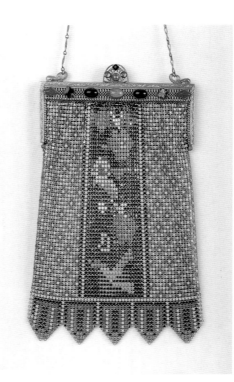

Top left: From the treasure chest: blue stones on a dull silver frame, blue diamond accent on silver mesh. $275-325.

Top right: Medieval splendor: a tapestry-like central panel on the mesh boasts a floral motif. The gold metal frame is studded with raised jewels. $325-375.

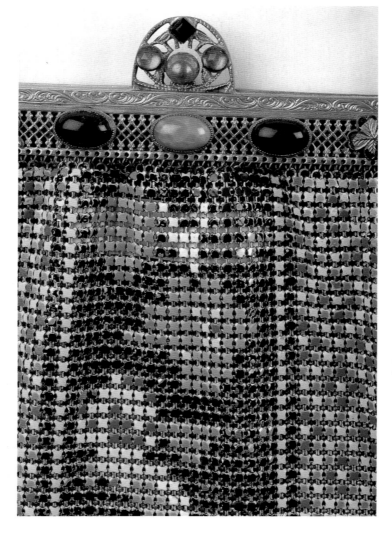

Raised jewel and floral panel detail.

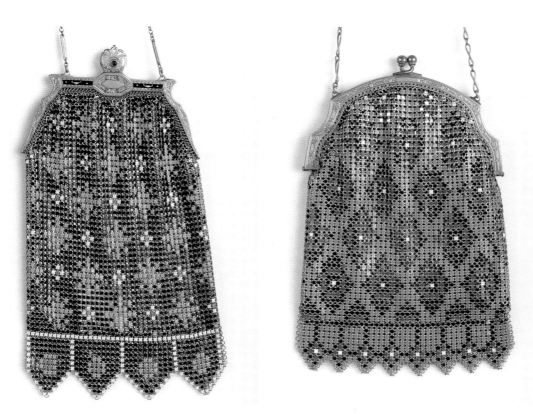

Top left: Dome frame with enameled decoration, jewel at clasp. The mesh pattern, gold and white snowflakes on black. $275-325.

Top right: A dome above, orange and black diamonds on green below. $225-275.

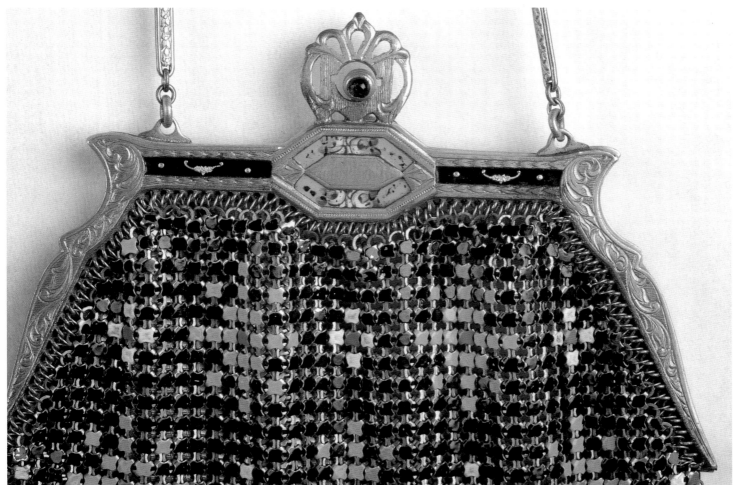

Detail, dome frame and snowflakes.

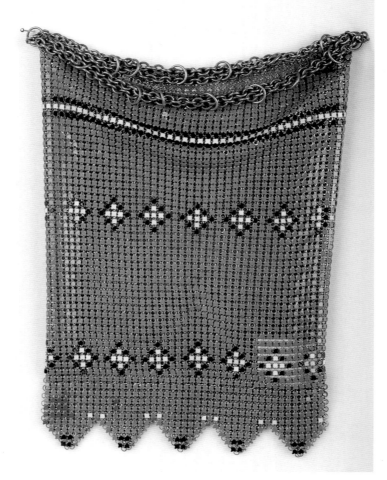

A silver draw chain replaces the traditional frame on a periwinkle blue reticule dotted with white crosses. $225-275.

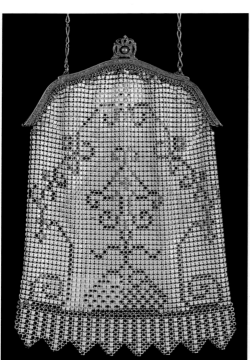

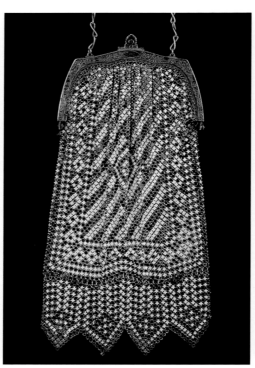

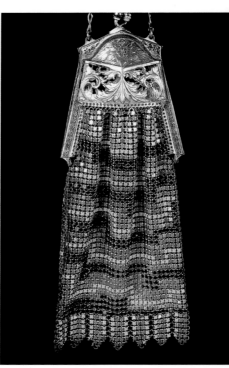

Under the silver dome frame, a stick figure abstract of showgirl in full skirt and elaborate headpiece. $225-275.

Diamonds and diagonal stripes in black and white below a domed frame. $175-225.

Deep dome frame with floral open-work on the metal. $275-325.

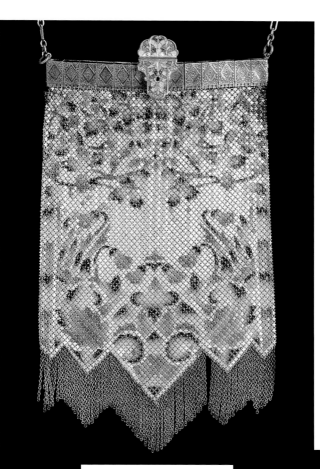

Top: Mandalian *Gloria Bag* with "bracelet frame". Individual bracelet-like links in the frame allow the bag to assume a box-like shape when open. $325-375.

Left: The open bracelet frame.

Right: A riot of color: *Gloria Bag* bracelet frame, claps, and mesh detail.

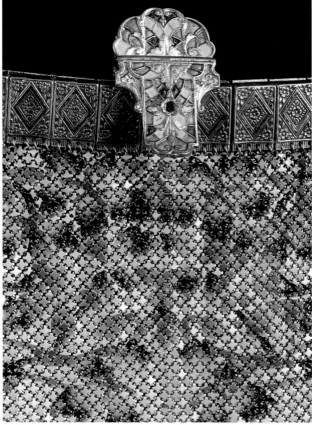

Chapter 8
MISH-MESH
Unusual Shapes & Stylings, Children's Bags, and Compact Purses

There are so many tempting things about Whiting & Davis Costume Bags! The eye-catching beauty of them. . .their smart social rating, gained from long intimacy with carefully costumed women. . .that precious quality of jeweler-crafstmanship which has always made each of them a flattering and enviable possession. But now comes a new form of temptation...
> Ladies' Home Journal
> October, 1929

For devotees of Whiting & Davis, temptation was always close at hand. Subtle changes in shape, novel clasps and handles, adorable children's or miniature purses, deluxe vanity bags—each new addition to the line attracted attention. And each, once seen, was a temptation not to be resisted.

Shaping Up

Entirely new shapes from Whiting & Davis: they're inspirations from the Master Minds of Fashion.
> Ladies' Home Journal
> June, 1929

The "Master Minds of Fashion" at W & D soon found that tinkering with bag shape was one of the simplest means of tempting new and repeat buyers. Those weary of rectangles could turn to the "gate top," a pliant water-bottle like bag with a metal lid; when the lid is removed, a gate-like opening expands for use. "Batwing" bags combined both flat and ring mesh, creating an interesting, graceful, effect. Other shape variations included bags with flat,

The open gate, in gold.

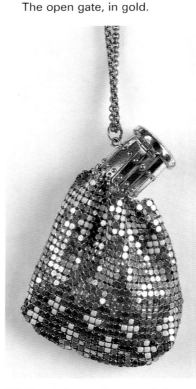
Whiting & Davis silver mesh "gate top" bag dating from the 1940s. When the cap is removed and the gate expanded, a larger opening is formed. $100-125.

untrimmed bases, bags with a border of flaps, bags with stepped or apron-like skirts, and bags with single or triple-point bases, a construction especially prevalent among Mandalians.

The "pouch," by Parisian designer Paul Poiret was one of the most successful Whiting & Davis shape innovations. Poiret first gained fame with a crusade to rid the fashion world of corsets, then moved on to mesh. Introduced in the late 1920s, the *Poiret Pouch* emphasized a wide-based horizontal, rather than vertical line. Poiret promoted the bags himself, appearing in an extensive series of W & D ads; he managed to loosen up things in this new arena as successfully as he had in others.

On Top Of Things

Clasps, handles, and straps provided temptation of a less obvious, but still enticing, sort. Variations on the standard ball-and-socket and twist-lock knob clasps included barrel slides, side-mounted latches, and the gate top. Decorative stones or enameling complementing the mesh also provided clasp variety.

Unusual among handles was a rigid model which folded down when the bag was open. More traditional handles and straps included straight or twisted link carry chains, interwoven rings, snake chains, and silver cord straps On the *Dansant* model, a silver cord joins a larger purse with a smaller one, creating "the latest whim of Paris." As with clasps, carry chains were often enhanced with the addition of

colored stones or even Bakelite beads, providing "that combination of smart daintiness."

Just Kidding

Even little sister can flaunt her cute Princess Mary Miniature alongside Mother.
Ladies' Home Journal
December, 1923

Tempting the inner child, most children's mesh bags are best-described as "miniatures"—pint-sized versions of the same bags that were available in full-scale versions for adults. Children's purses were billed as "grown up in every way but in price." Even the lavish *Delysia* vanity bag had its youthful counterpart, the *Baby Peggy*, named for early child star Diana "Peggy Montgomery" Cary. The only bags geared directly to younger tastes were those decorated with cartoon characters, such as Mickey Mouse, or the Shirley Temple bag "with Shirley's picture on the back of the mirror!"

Children's mesh bags average in length from 3-1/2" to 5-1/2"; the size is perhaps all that distinguishes them from those miniature purses designed specifically for adults which are in the 2" to 3-1/2" range. Miniatures and children's bags are usually readily distinguishable from coin purses, which are even smaller, have no carry chains, and generally have rings used to attach them to the interior of a larger purse.

In the 1970s, a short-lived disco fad saw miniature mesh bags suspended on neck chains, and reborn as flashy coin purses.

Today, small bags are not particularly plentiful, since they often were not handled carefully by their original young owners (or by their "Saturday Night Fever-ed" successors).

Early ads trumpeted miniature bags as ideal "for the wee girl." Today, when found, they remain popular with girls not so wee.

Ring them bells: circular-framed bag with celluloid, bell-shaped slide. $550-650.

Inner beauties

The vanity, or compact "function" bag proved tempting to those who wanted a bag to be more than just a receptacle. Compact bags gave the customer more for her money—rightly so, considering the prices. Standard equipment for the mesh vanity included a powder and/or rouge compact, a mirror, and various "extras' such as a comb or lipstick compartment. A W & D favorite of the early 1920s was the ring mesh *Piccadilly,* with dome top and exterior compact. The *New Piccadilly* also featured an exterior compact, but was distinguished by its design of an enameled rose on armor mesh. The perennial *Princess Mary* gained new life as the *Princess Mary Dansant*, now with the addition of a smaller flap bag, specifically for vanity items, attached to the main bag with a silver cord. And, a rare "double purse," patented for the firm in 1925 by designer Harry B. Rowan, offered separate hanging mesh pockets surrounding central compacts.

Especially desirable (and expensive) was the *Delysia*, with mesh pockets attached above and below a central hinged hard compact. A center-mounted top strap and elaborate hanging tassel complete the *Delysia's* resemblance to an ornate Faberge Easter egg. Not for the tightfisted, the price of a top-of-the-line *Delysia* could soar to the then-exorbitant sum of five hundred dollars. Moms who still had money to burn could also pick up a junior version, the *Baby Peggy*, for their daughters.

The compact bag craze extended well beyond Whiting & Davis to such competititors as Evans, Napier, and R & G. Their ongoing appeal was recognized in 1996 with the release of *The Compact Handbag Trio* marking the 120th anniversary of Whiting & Davis. Designed by Lèlia S. Teixeira and Susan Luccini, the three bags—"Libby," "Christine," and "Lizzie"—had exterior compacts, and vintage styling in gold or platinum mesh. The limited edition bags were available exclusively through the Whiting & Davis Museum, and marked the third special anniversary release, following the "Star Series" in 1976, and "Toys in the Attic" in 1986.

Compact bags, children's bags, gate tops and pouches. No matter the shape styling, form or function, in the world of mesh bags, the temptations are many (and never-ending!)

The Whiting & Davis mesh bag: a new form of temptation. How can any feminine heart resist?

Ladies' Home Journal
October, 1929

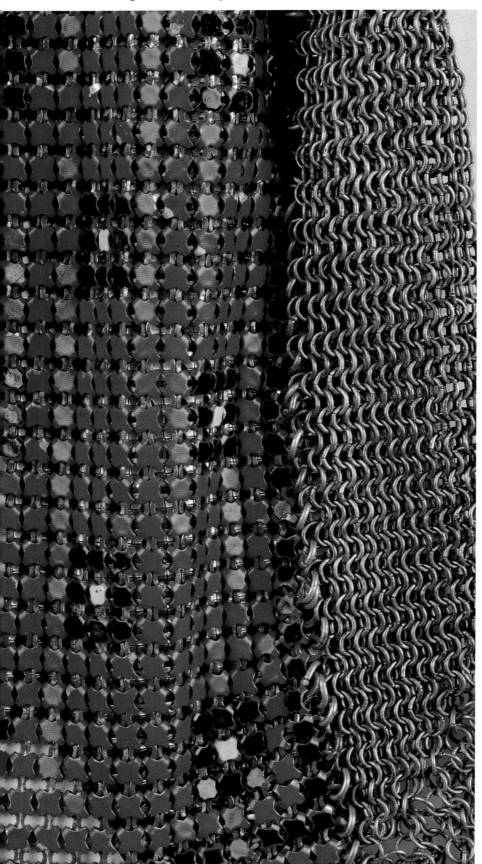

Half and half: detail, flat and ring mesh blend.

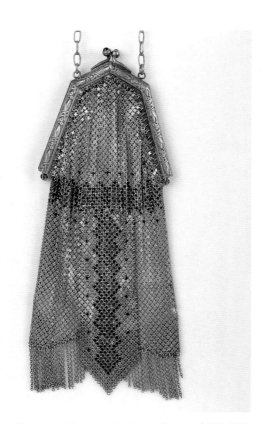

Silver "batwing" bag with dome frame. $225-275

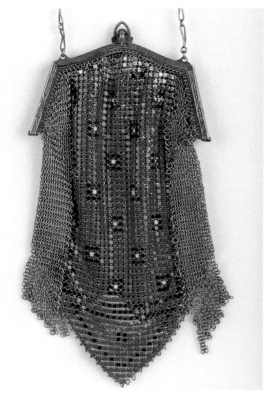

Mix 'n Mesh: the batwing in red enameled flat armor mesh with ring mesh border. $300-350.

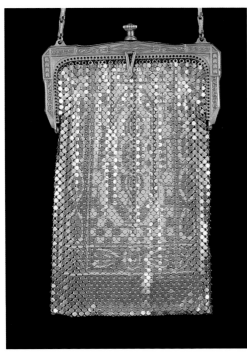

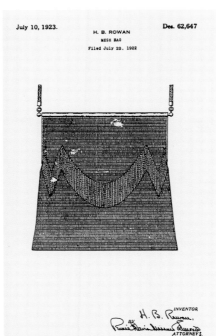

Top left: Jazzy gold and orange flat-based bag with gold enameled frame. $150-200.

Top right: 1923 W & D patent for flat-based mesh bag.

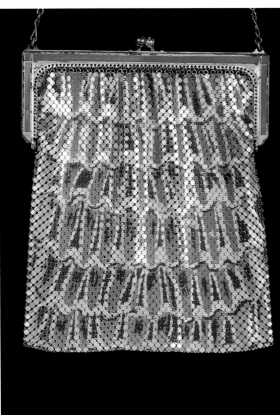

Flat-based bag with brushstroke pattern, in green and aqua $200-250.

Detail, green and aqua brushstrokes.

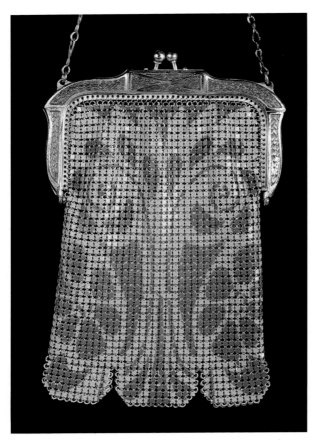

Tri-flap base on bag with turquoise floral motif.
$175-225.

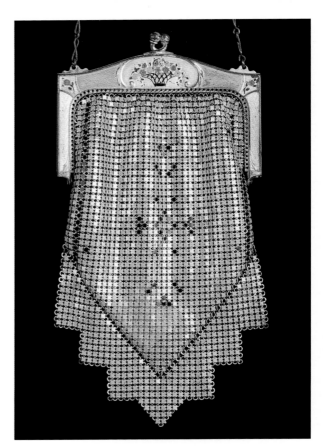

Novel apron-like base, with stepped levels converging in a central point. On the frame, an enameled flower basket. $275-325.

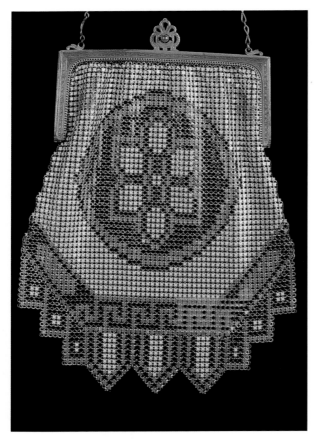

Still steppin': the wider apron skirt of this bag allows three points at the base of the stepped levels. $275-325.

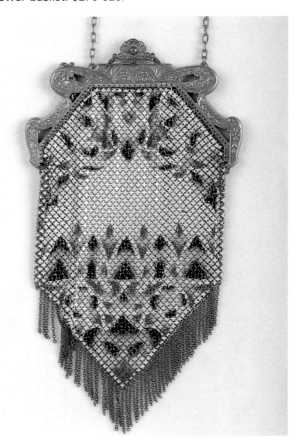

The fringed "V" base, a Mandalian standby, below green and red alternating triangles and crescents. $300-350.

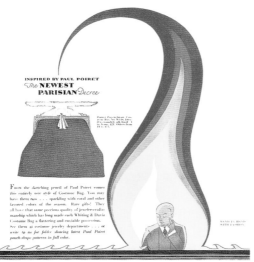

POIRET POUCH SHAPE
COSTUME BAGS

CREATED BY
WHITING & DAVIS CO.

World's Largest Manufacturers of Costume Bags
Makers of Costume Jewelry for Everyone

Factories at Plainville, Norfolk County., Mass.
In Canada: Sherbrooke, Quebec

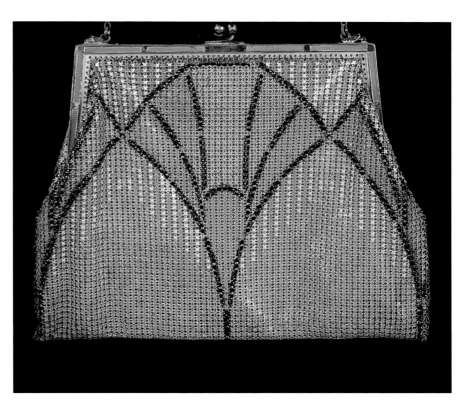

The *Poiret Pouch*, with Egyptian palm fan motif. $225-250.

Above: Fanning the flames: the Whiting & Davis "pouch" by Parisian designer Paul Poiret, introduced in this 1925 ad.

Alice White
First National Stars

A New Form of Temptation

"An entirely new shape which has captured Paris and created a new style!" The *Poiret Pouch*. Screen star Alice White liked it. You will too. *Ladies' Home Journal*, October, 1929.

*T*HERE are so many tempting things about Whiting & Davis Costume Bags! The eye-catching beauty of them . . . their smart social rating, gained from long intimacy with carefully costumed women . . . the gay Parisian finesse of them, inspired by the personal designs of Paul Poiret . . . and that precious quality of jeweler-craftsmanship which has always made each of them a flattering and enviable possession!

But now comes a new form of temptation to own another Costume Bag—the Paul Poiret pouch-shape —an entirely new shape which has captured Paris and created a *new style!* How can any feminine heart resist!

Hand in Hand With Fashion

For Gifts That Last, Consult Your Jeweler. Look for this trade-mark in miniature stamped on the frame of each genuine Whiting & Davis Costume Bag. It is the hall-mark of excellence which stands for more than 30 years of creative craftsmanship.

See Them at Costume Jewelry departments . . . made with our Beadlite, Armor, Petite Armor and Dresden enameled mesh or in the sheer beauty of gold and silver woven to silken fineness. Write to us for a folder showing the latest Paul Poiret models in full color.

WHITING & DAVIS
COSTUME BAGS

WHITING & DAVIS COMPANY
World's Largest Manufacturers of Costume Bags
Makers of Costume Jewelry for Everyone
PLAINVILLE (NORFOLK COUNTY), MASS.
In Canada: SHERBROOKE, QUEBEC

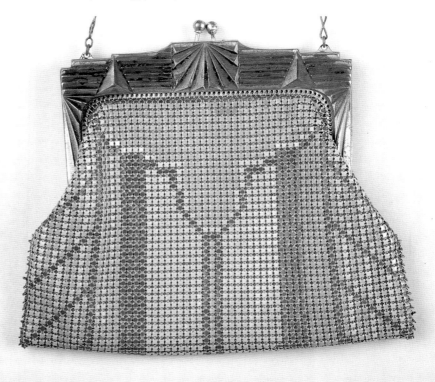

The pouch in pastel pinks and greens. $200-225.

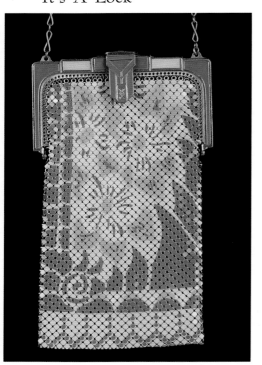

Green daisies, on bag with front metal latch. $175-225.

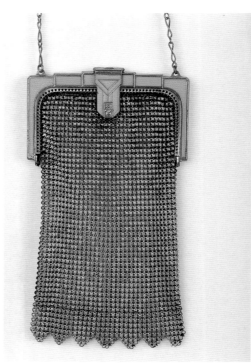

The same latch on an orange and yellow beadlite bag. $175-225.

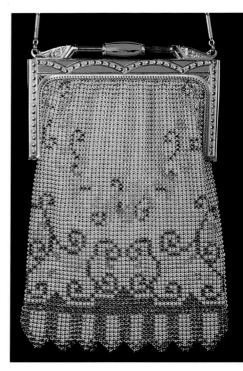

All safe and sound, thanks to a blue enamel slide clasp. $225-275.

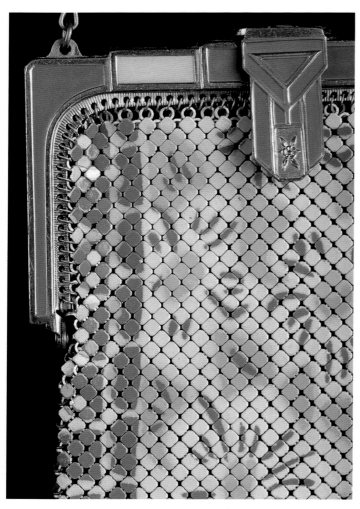

Latch Lond daisy detail.

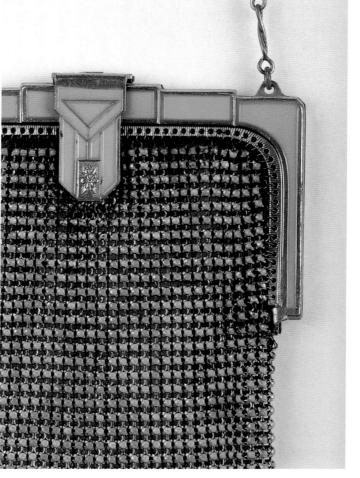

Beadlite/ latch detail.

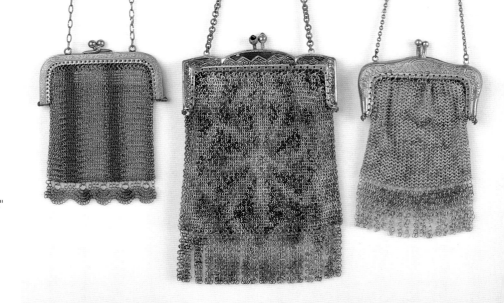

Three in Dresden mesh. Children's purses average in length from 3-1/2" to 5-1/2". $125-150 each.

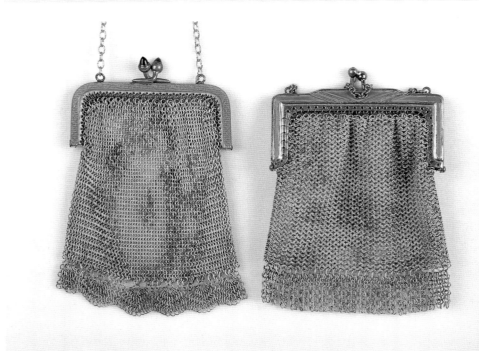

Two child-size Dresdens with enameled frames picking up colors in the mesh. $125-150 each.

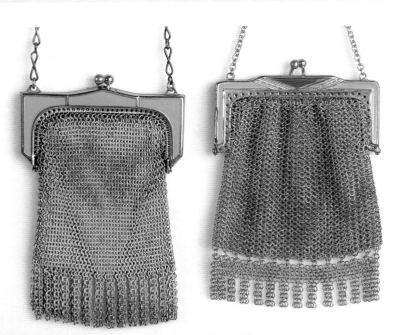

Children's Dresdens in pastels and gold. $125-150 each.

Opposite page, Top: Three children's purses in greens and blues that mimic adult styles. $100-125 each.

Bottom: Three more for the younger set, by Mandalian. $125-150 each.

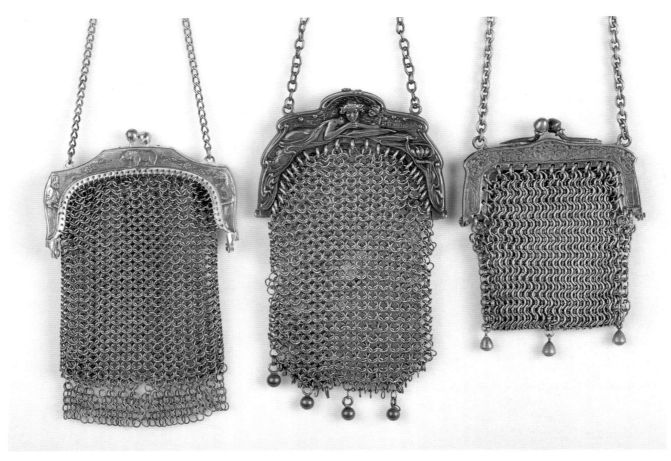

Silver ring mesh miniature purses with ornately embossed frames.
Miniatures average from 2" square to 3 x 3-1/2". $175-225 each.

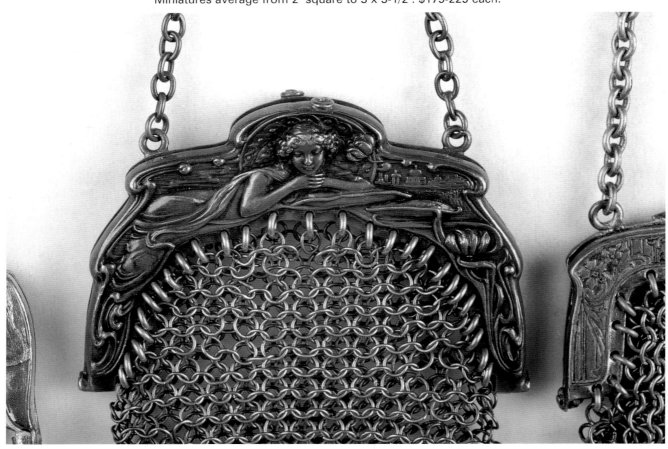

Detail of center frame, with Art Nouveau-influenced female figure.

Sheer Vanity

Three delightful *Delysias*, open to illustrate the three-dimensionality of the bag design. $700-900 each.

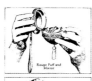
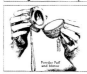
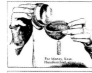
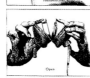
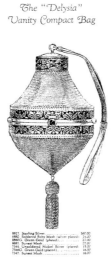

The "Delysia" Vanity Compact Bag

The delicious *Delysia*. A Whiting & Davis catalog illustration from the early 1920s, depicting this unique version of the vanity bag. The powder puff, rouge puff, and mirror are in the center section; the mesh pockets at top and bottom provide storage.

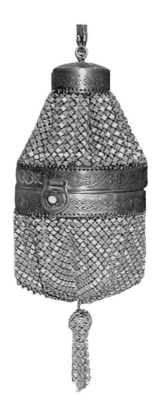

Mid-size "junior" *Delysia*, enameled in blue and white. Other sizes were "standard" and "petite". $675-775.

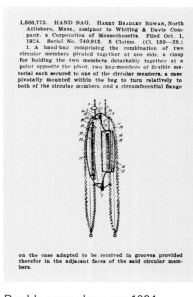

Double your pleasure: 1924 patent for a Whiting & Davis double vanity bag. The two mesh bag sections are separated by a central panel containing a mirror and other makeup essentials.

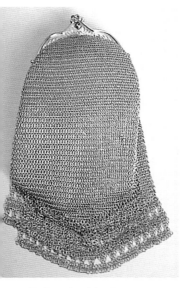

Doing double duty: sensational silver double vanity bag, with double-fringe skirt. $1900-2100.

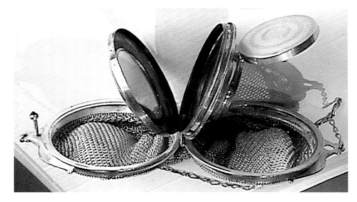

Silver double bag in open position.

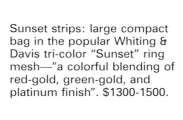

Sunset strips: large compact bag in the popular Whiting & Davis tri-color "Sunset" ring mesh—"a colorful blending of red-gold, green-gold, and platinum finish". $1300-1500.

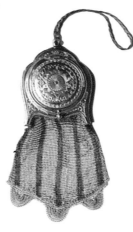

Two by two: each side of these *New Picadilly* rose-motif bags has a separate compact opening—one for rouge, one for powder. Pulling down on a small metal drop opens the compartments. $1000-1200 each.

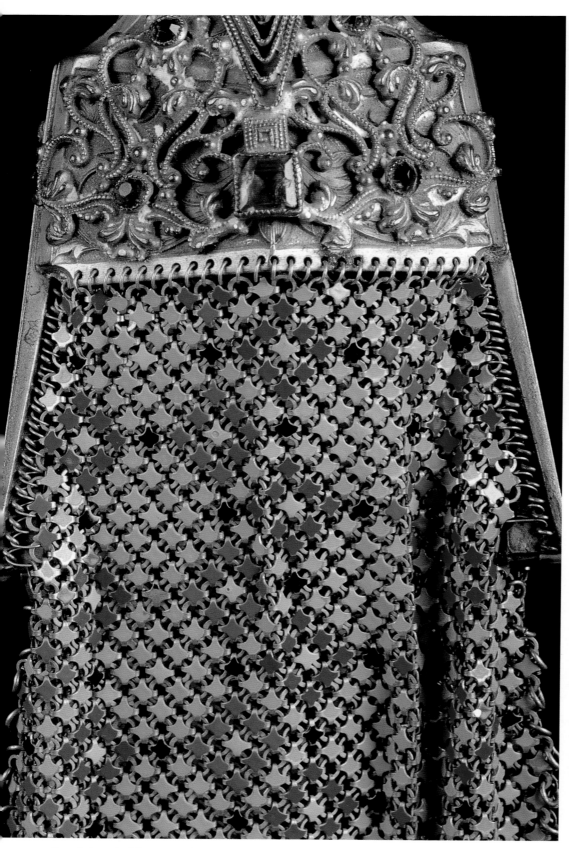

Detail, jeweled frame and brightly colored mesh.

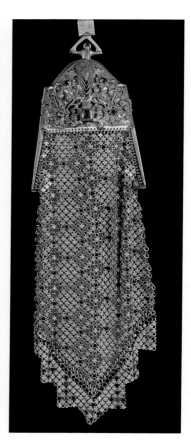

Oriental splendor: double compact bag in rich blues and reds on gold. $700-800.

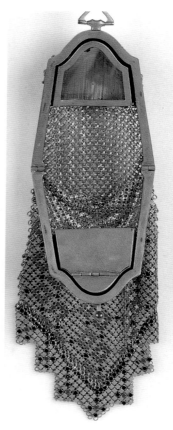

Interior detail.

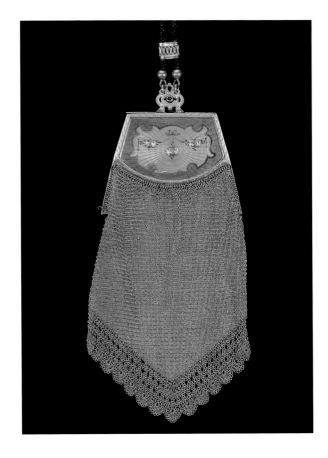

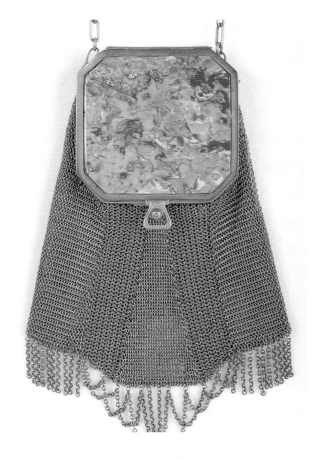

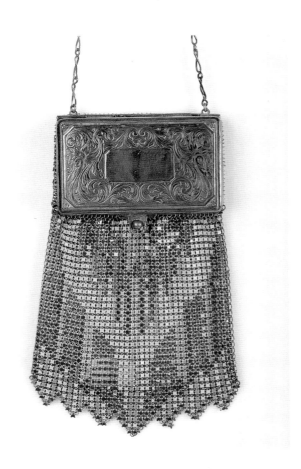

Top left: Blue enameled compact and fine enameled ring mesh in a soft copper shade. The "Renaissance Filigree" fringe dates the bag as mid-1920s. $550-650.

Top right: Faux marble compact, silver ring mesh bag. The tag is marked "made in France". $500-600.

Bottom right: Rectangular silver compact atop bag with pink and blue decoration, vandyke skirt. $450-550.

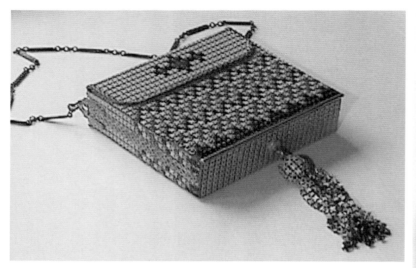

All boxed up: hard-box mesh compact purse, $550-650.

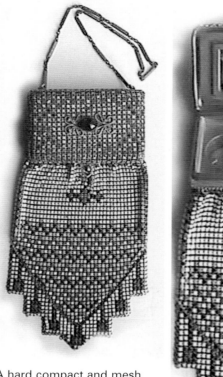

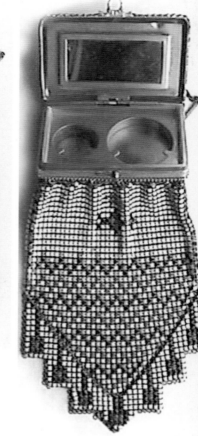

A hard compact and mesh bag combo. The inset stone adds to the value. $900-1000.

Hard compact interior.

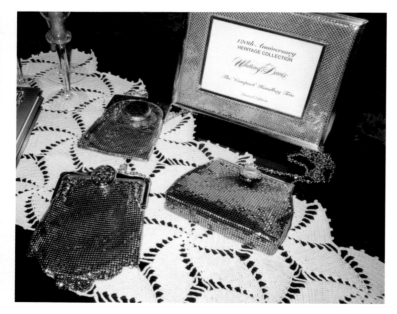

The Compact Handbag Trio. $350-450 each.

In 1996, Whiting & Davis marked its 120th anniversary with the debut of *The Compact Handbag Trio.* Designed by Lèlia S. Teixeira and Susan Luccini, the compact bags revisited classic W & D themes.

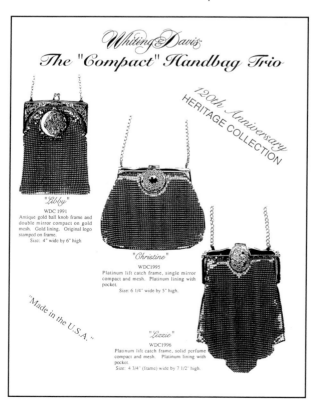

Whiting & Davis
The "Compact" Handbag Trio

120th Anniversary HERITAGE COLLECTION

"Libby"
WDC 1991
Antique gold ball knob frame and double mirror compact on gold mesh. Gold lining. Original logo stamped on frame.
Size: 4" wide by 6" high.

"Christine"
WDC1995
Platinum lift catch frame, single mirror compact and mesh. Platinum lining with pocket.
Size: 6 1/4" wide by 5" high.

"Made in the U.S.A."

"Lizzie"
WDC1996
Platinum lift catch frame, solid perfume compact and mesh. Platinum lining with pocket.
Size: 4 3/4" (frame) wide by 7 1/2" high.

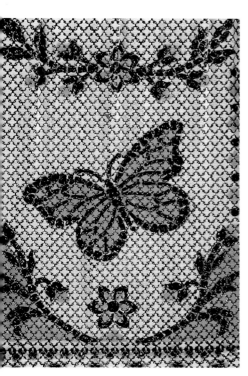

Butterfly detail.

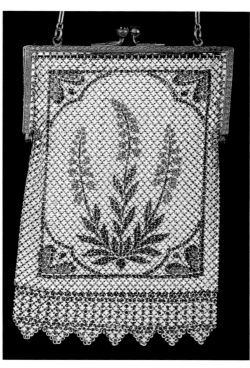

Rose-colored ferns with forest-green leaves on white. $275-325.

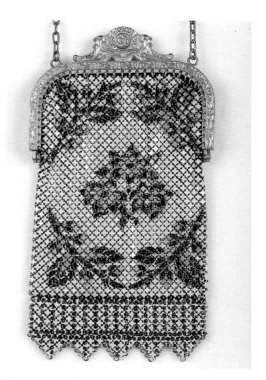

Nosegay and leaves in gold and green. On the frame, embossed birds keep watch. $275-325.

Detail, frame with birds.

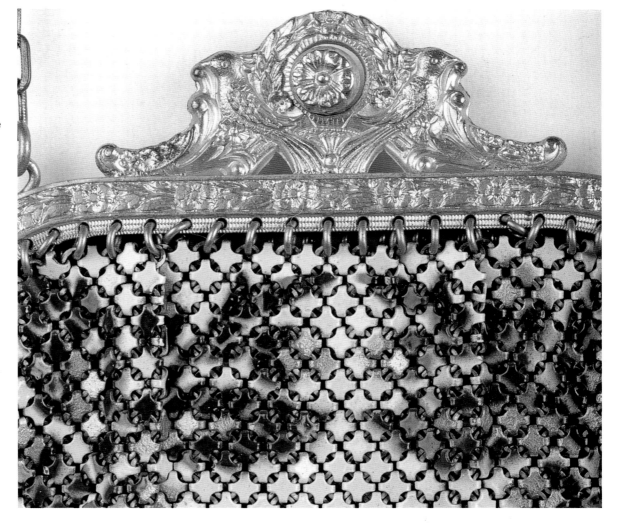

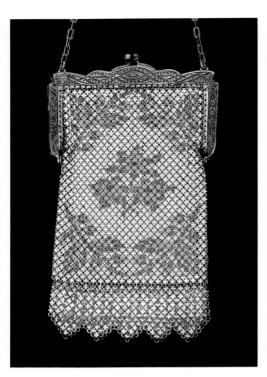 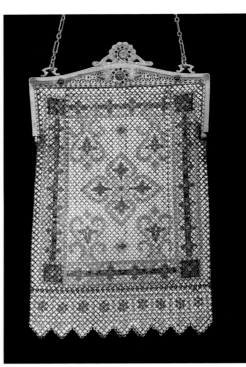 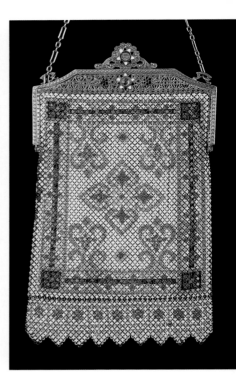

The same bunch of flowers shown on the previous page, in pink and yellow. $275-325.

Hearts and flowers in blue and tan on white, frame set with blue jewels. $300-350.

The same pattern in an alternate colorway, with jeweled pinwheel on frame. $300-350.

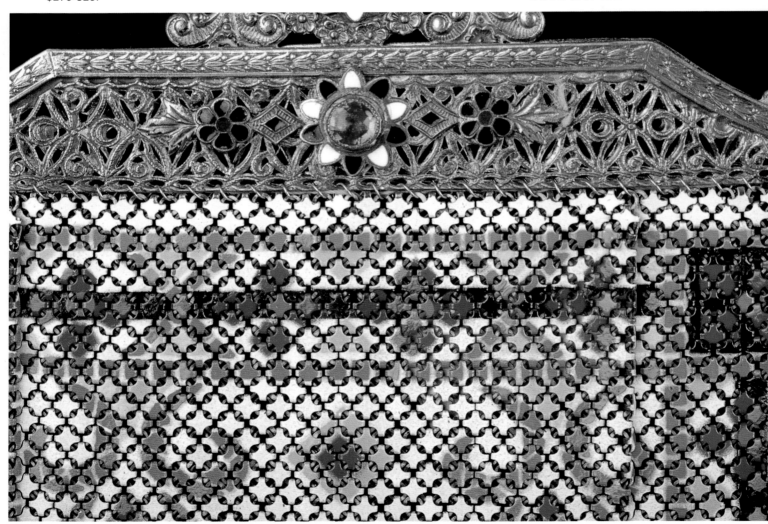

Jeweled pinwheel detail.

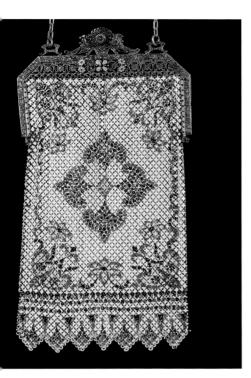

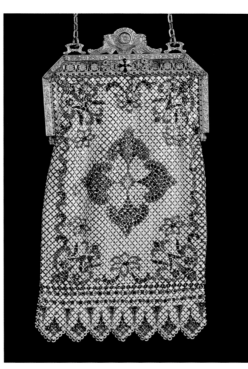

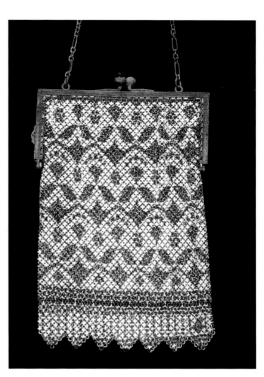

Magic carpet ride: Oriental rug pattern with blue central medallion. $275-325.

Seeing double: the same bag, with the same frame in gold. $275-325.

How does your garden grow? Repeating rows of abstract flowers in blue on white. $275-325.

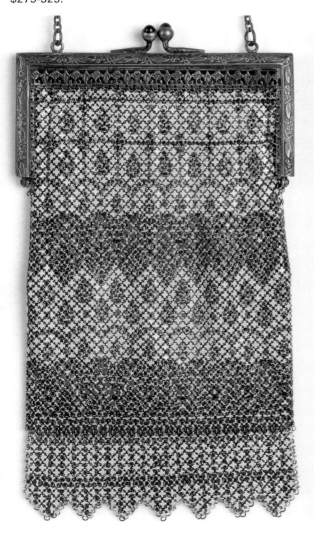

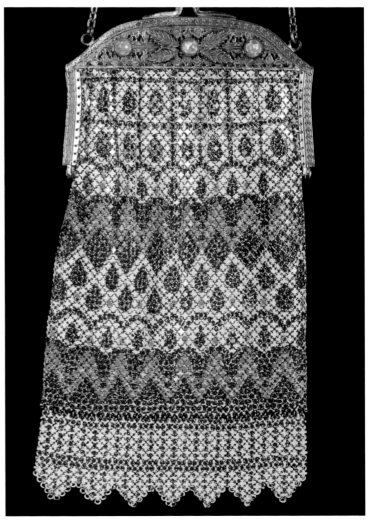

High seas: blue waves with water droplets on ivory. $275-325.

Here the waves are pink, the water droplets black, the frame studded with mottled pink stones. $300-350.

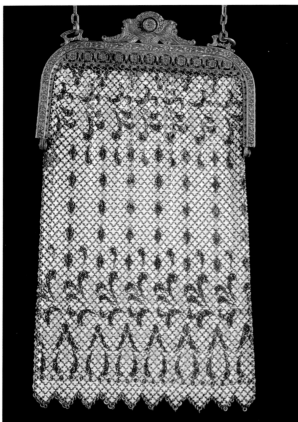

It's raining, it's pouring: forest green and yellow raindrops on white. $275-325.

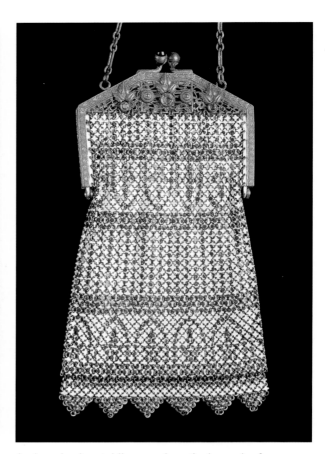

Arches, horizontal lines and verticals, and a frame with three embedded amber jewels. $300-350.

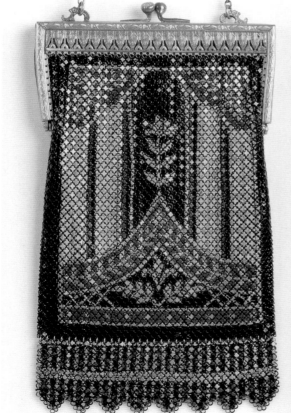

Royal splendor: medieval architectural panel in black, gold, and teal. $325-375.

Panel detail.

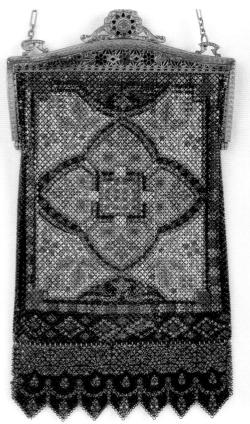

Regal rug: Persian carpet design in green, blue, and black jewel tones. $325-375.

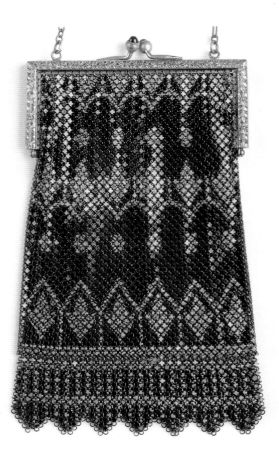

Gold on shiny black, with black jewels set in the clasp points. $300-350.

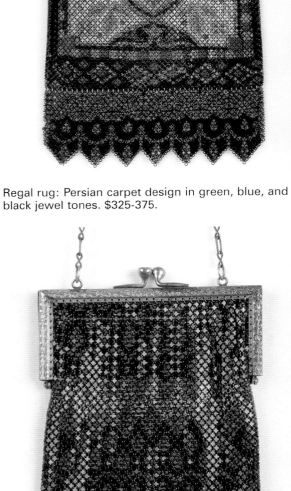

Black and gold zigzags on blue. $300-350.

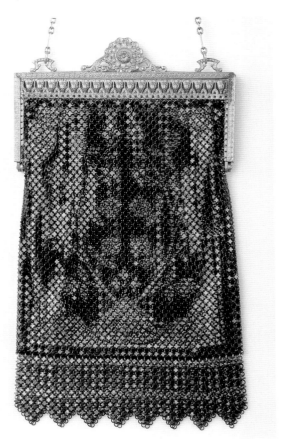

Gold and magenta flowering vine on black. $300-350.

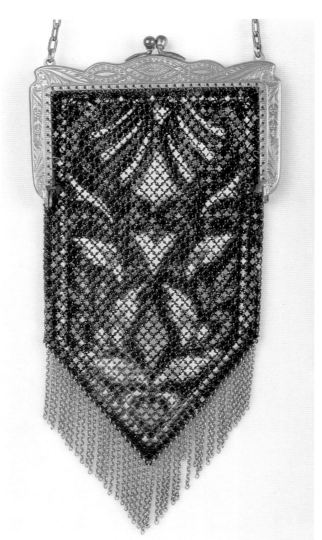

Stylized cathedral window in gold and white on black. The "V" base is enhanced by ring mesh fringe. $300-350.

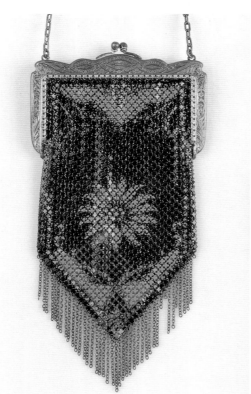

A similar "V" shape, with central image of a turquoise and gold daisy. $300-350.

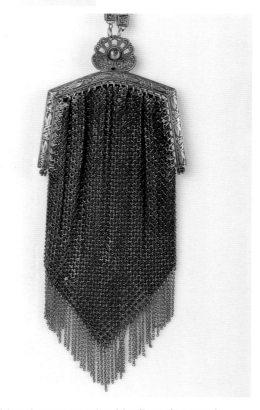

Solid teal-green mesh with silver ring mesh fringe. $275-325.

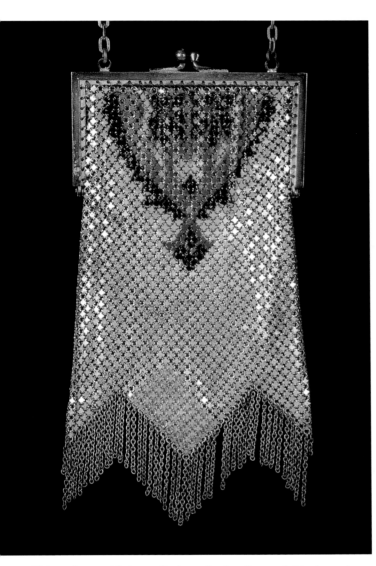

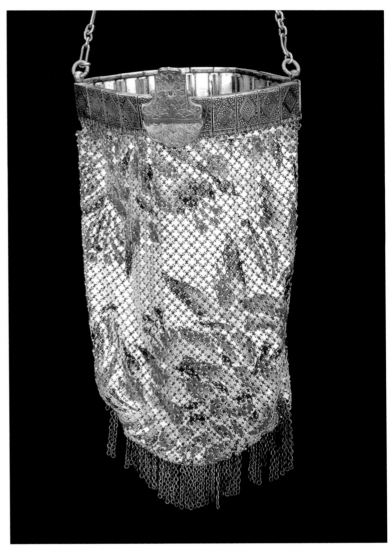

Shiny silver, with butterfly inset in dazzling red, black, and yellow. $375-425.

Manadalian bracelet frame *Gloria Bag* dotted with oversize tropical flowers. $325-375.

Don't scare them away:
the bluebirds, up close.

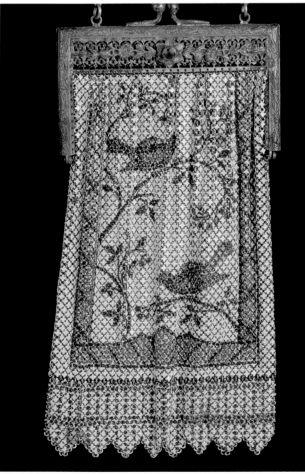

Watch the birdies: bluebirds perched on
branches, as viewed through a window.
$350-400.

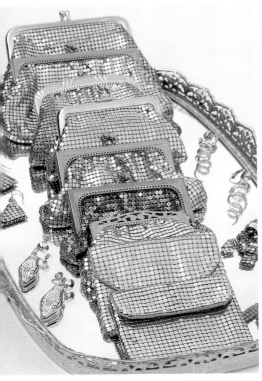

Golden dreams: assorted newer gold mesh coin purses, $10-20 each.

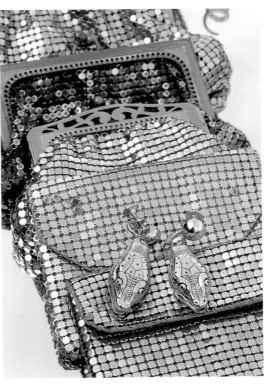

Gold dust: coin purse detail, plus a pair of gold snake earrings, $10-15.

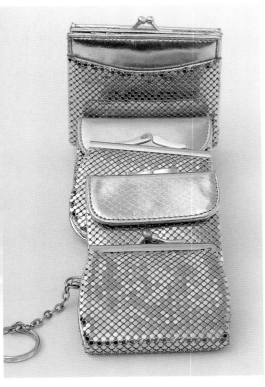

Pocket change: gold mesh coin purses, $10-20 each.

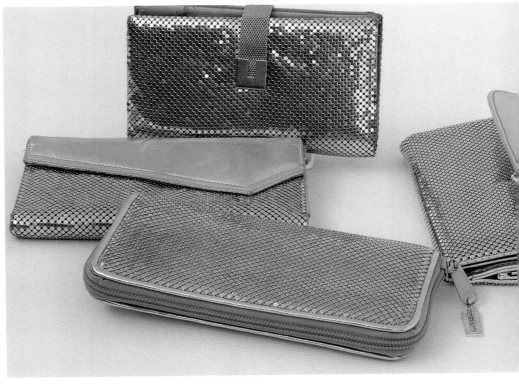

Engaging clutches: gold clutch bags, $20-30 each.

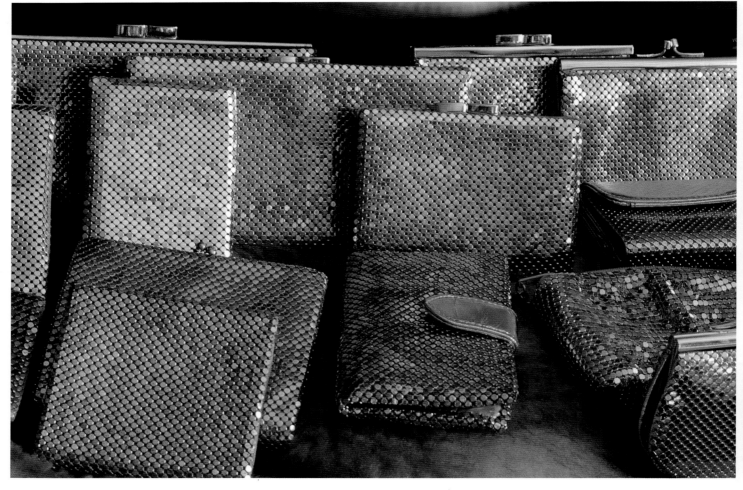

Wallet world: a bevy of wallets in gold, $15-25 each.

Whiting & Davis display sign promotes large gold wallet, $20-30, and cosmetic bag with gold tiger stripe, $25-35.

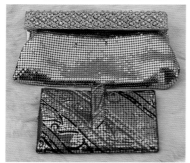

Sparkle plenty: gold bag with rhinestone-dotted frame, $70-80; gold belt loop bag with brightly-colored enameling, $20-30.

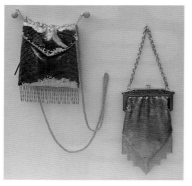

Deco revisited: two new bags with fringe treatments reminiscent of Whiting & Davis bags of the 1920s & '30s. $70-80 each.

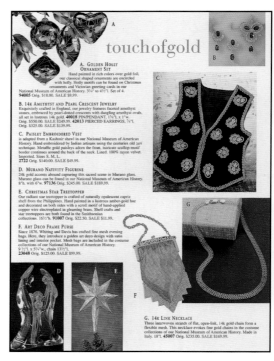

A touch of gold: a page from the 2000 *Smithsonian* holiday catalog, offering the "V"-base bag shown in the previous photo. As noted in the description, mesh bags are included in the costume collections of the National Museum of American History.

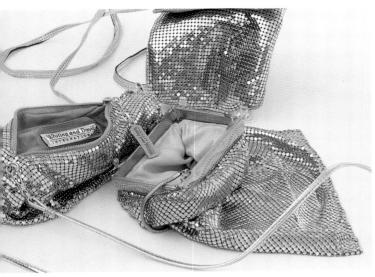
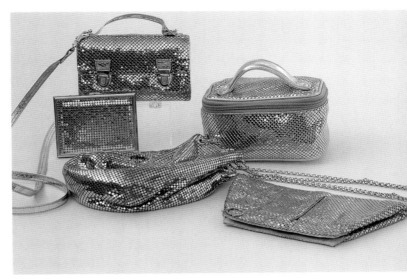

Above & following: Golden opportunities: a glittering gathering of gold mesh possibilities from Whiting & Davis. $20-40 each.

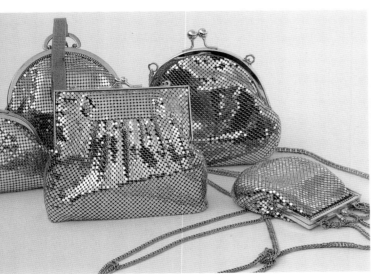
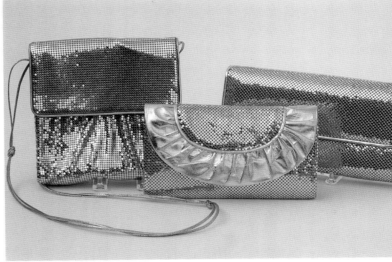

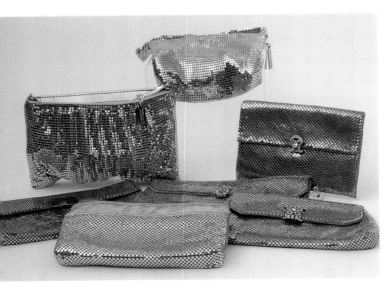
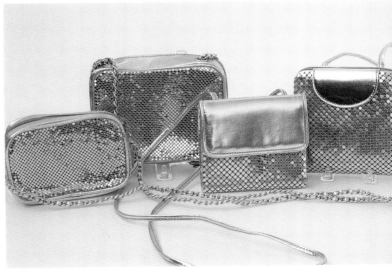

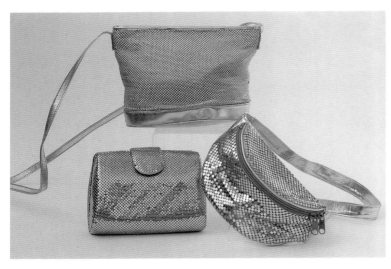

Something for every occasion: gold mesh evening bag, day purse, and belt bag. $15-30 each.

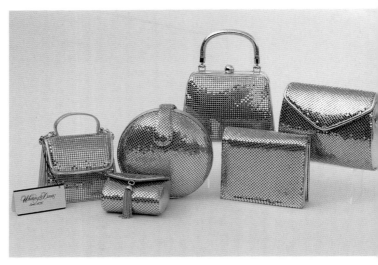

The gold standard: evening bags, $25-45 each.

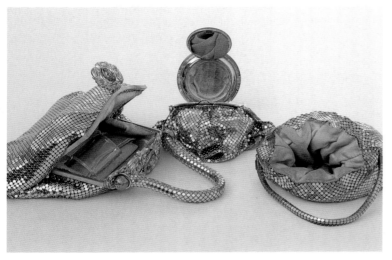

Gold mine! *From left*: bag with ornately jeweled clasp and snake chain, $100-125; compact bag (open), $125-150; pouch with snake chain, $75-100.

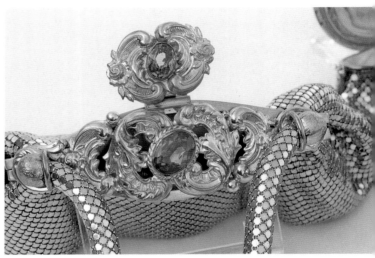

Treasure hunting: jewel clasp detail.

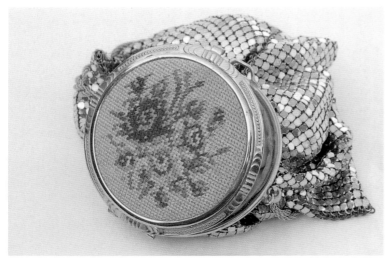

Detail, compact bag needlepoint lid.

Gold rush! A November, 1997 *Cosmopolitan* model shows all the symptoms of gold fever in an ensemble that includes a luminous Whiting & Davis chain-mail dress and mesh bag.

Chapter 11
MESH MATES
Bibs, Belts, & Baubles

In 1912, the mesh bag business had assumed such proportions that it was considered best to separate it from the jewelry manufacturing end. The Whiting Chain Company was formed to carry on the latter. This concern, operating along the same broad, square-deal principles which had so much to do with the success of the parent firm, has already won wide recognition and success in its particular field.

WADCO News
"Golden Anniversary
Number," 1926

As long as you're selling to jewelers, why not make the most of it? Like many mesh manufacturers, Whiting & Davis began as a jewelry-making concern; with the overwhelming success of the mesh handbag, the company's focus became diluted. Spinning off the jewelry division into the newly-created Whiting Chain was a logical means for W & D to maximize its resources, and continue offering jewelry items "of unusual interest and sales appeal." At the same time, the Whiting & Davis parent company could supplement its handbag reper-

Works with any outfit! $20-30.

toire with such related mesh items such as bibs, bandanas, and belts. (During the 1930s in particular, scarf-like mesh accessories that matched the handbag were in vogue, and in demand.)

Jewels in the Crown

The newly-formed Whiting Chain offered jewelry selections for men ("Waldemars, Belt Chains, Watch Bracelets"), for women ("Bracelets, Festoons, and Chains"), and even for the observantly religious ("Rosary Cases and Bags"). As with Whiting & Davis mesh bags and related accessories, customers were advised, "For Gifts That Last, Consult Your Jeweler."

Whiting Chain Company manufactured jewelry until the mid-1930s, but even well into the 1990s, the Whiting & Davis catalogs continued to offer a wide assortment of mesh fashion and jewelry items, ranging from tunics, halters, and vests, to "mesh shoulder duster swirl earrings," "Victorian mesh cuff bracelets" and "Tsarina mesh necklaces." Whiting Chain's promise of "unusual notes of beauty and novelty, made irresistible to the feminine fancy" lived on.

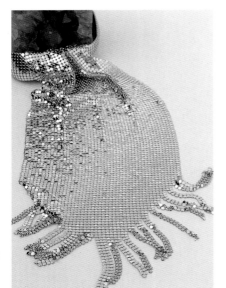

Festive fringed
bib, $20-30.

Whiting Chain Company, Creators of the Unusual: "Jewelry for Everyone."
Whiting Chain Co.
circa 1920

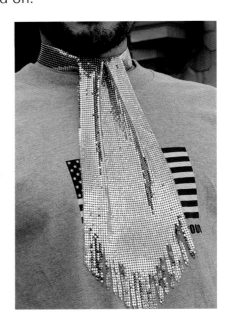

Bib detail.

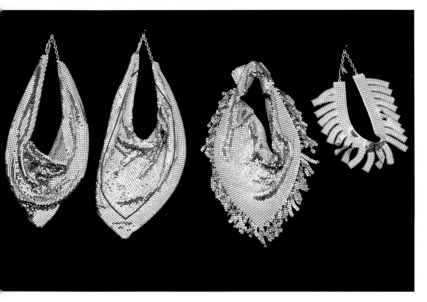

For the "bib-liophile"? Assorted gold mesh bibs, $20-30 each.

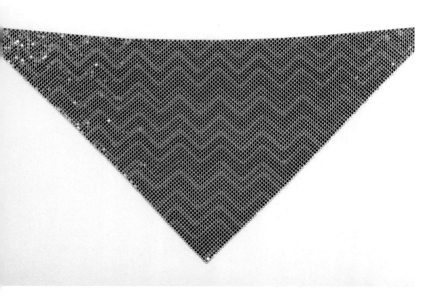

Bandana-mania! Gold mesh bandana with multi-color zigzag pattern, chain and hook clasp. $25-50.

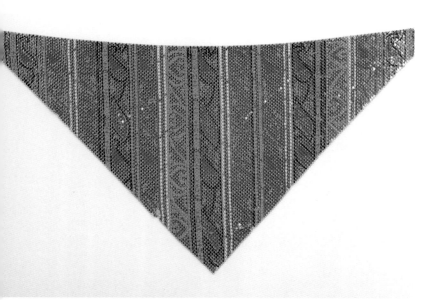

Multi-color vertical and loop design on gold mesh bandana. $25-50.

Zigzag pattern detail.

More verticals and loops on a matching belt.
$15-25.

Detail, verticals
and loops.

161

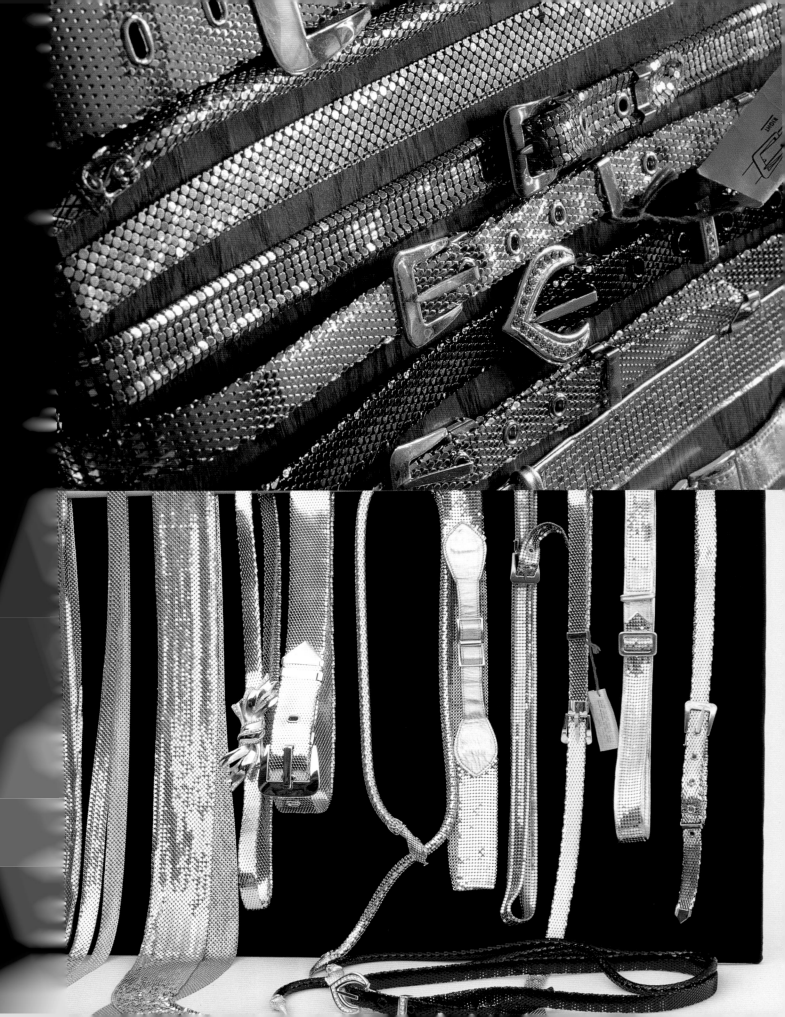

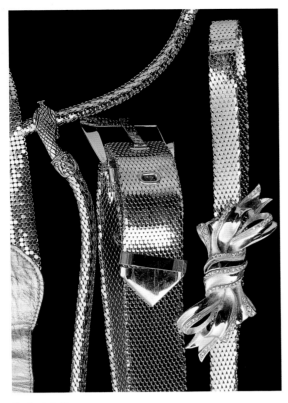

Belt detail.

The belt as a hatband. $15-20.

Opposite page, Top: All belted in: assorted mesh belts, $15-25 each.

Opposite page, Bottom: Belts on black velvet, $15-25 each.

Head trip: gold mesh Whiting & Davis headband in action. $40-50.

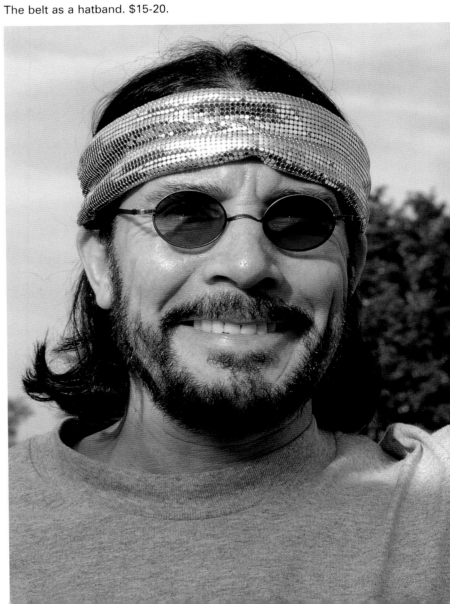

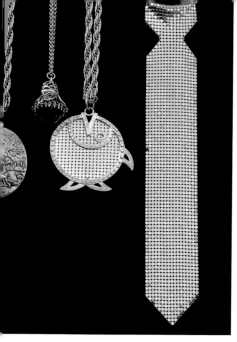

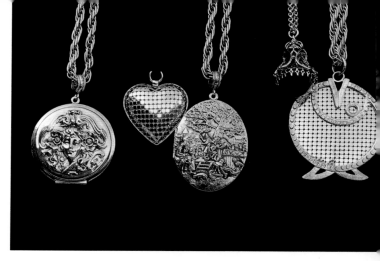

Necklaces and mesh "necktie." $20-30.

Traditional neckwear with a glittery touch. Necklace and locket assortment, $20-30 each.

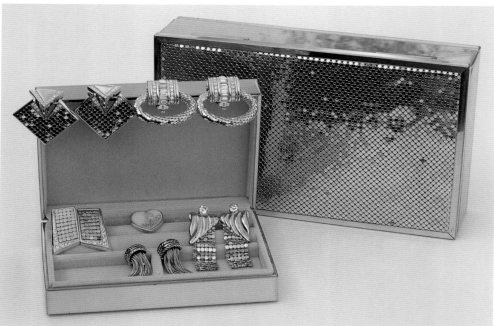

Glitter Gulch

Inside the jewelry box: gold mesh boxes, $15-25 small, $25-35 large. Earrings, $15-25/pair.

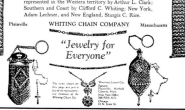

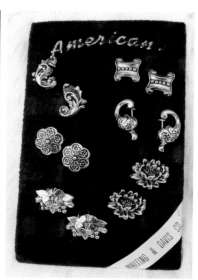

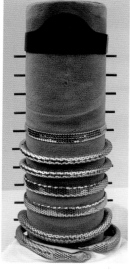

Left: In the beginning: early advertisement for the Whiting Chain Company, "creators of the unusual". In 1912, the company became a separate division of Whiting & Davis, and continued jewelry production into the 1930s.

Center: Pining for pins? Twelve decorative pins adorn an original W & D display board. $50-75.

Right: Bow-wow! "Dog collar" display column, with seven Whiting & Davis collars still in place. $125-150.

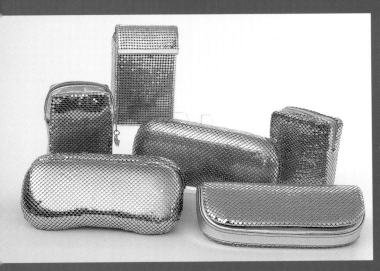

The eyes have it: assorted eyeglass cases, $30-50 each.

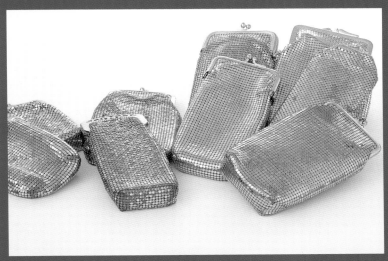

Smoke gets in your eyes: cigarette cases, $30-50 each.

It's got to be here somewhere! Among the Whiting & Davis purse accessories shown are: lipstick holders, compacts, a pen and pencil case, business card holders, perfume atomizers, purse mirrors, a luggage tag, an address book, and a paperweight! Prices range from $15-30 per item.

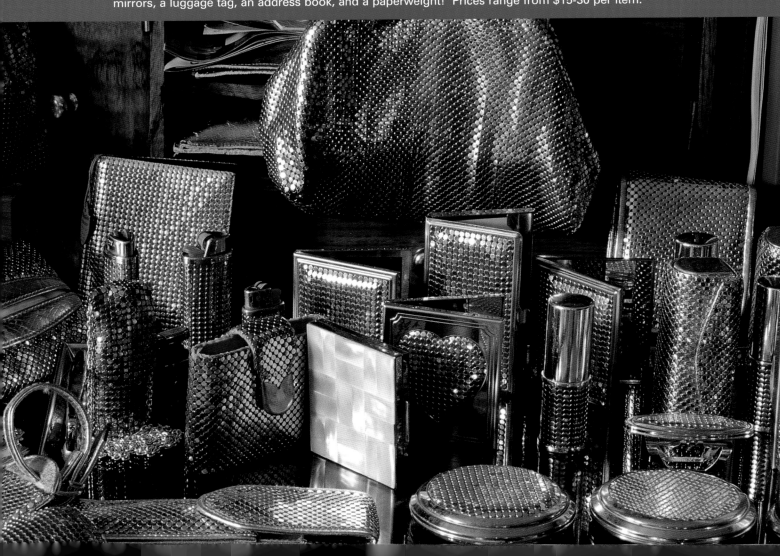

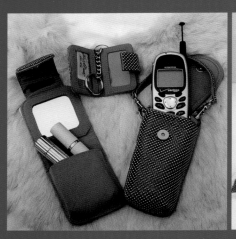

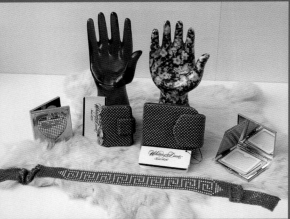

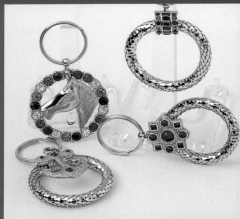

Up to the minute: accessories for today (in green bubble mesh) include a multi-lipstick holder, a photo key chain, and a cell phone case. Each, $15-30.

Accessory access! *From left*: heart photo holder, $15-25; purple-blue key holder and double lipstick case, $10-20 each; square compact, $15-25. In front, a red and white enameled mesh band, $15-25.

All keyed up: Whiting & Davis keychains. $15-20 each.

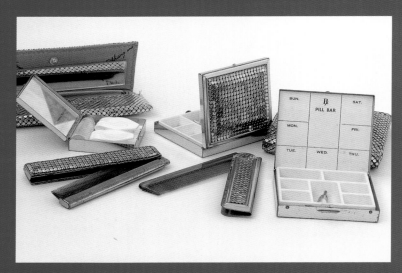

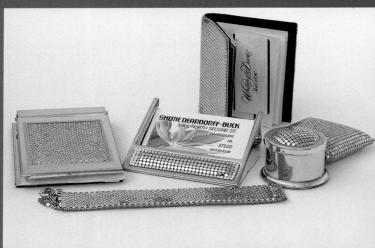

To your health! Contact lens case, combs and comb cases, pill cases. $15-30 each.

Getting down to business: desk accessories include a memo pad, bookmark, paperweight, business card holder, stamp container, and picture case. Each, $15-30.

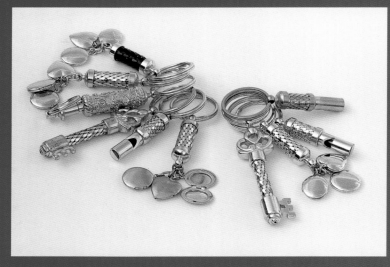

A flock of Whiting & Davis keychains, each one a "key-per". $15-20 each.

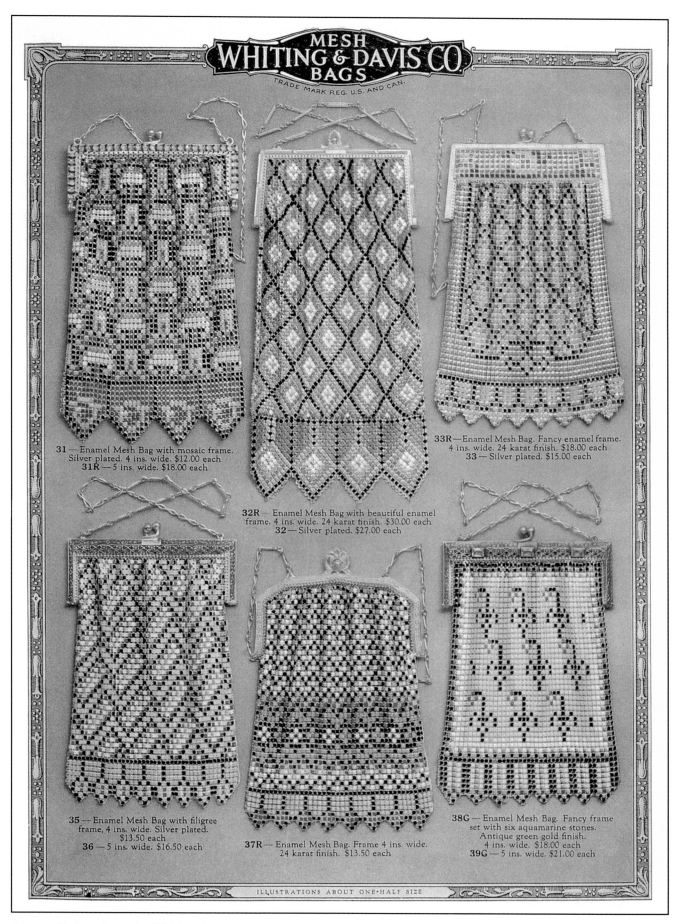

MESH WHITING & DAVIS CO BAGS
TRADE MARK REG. U.S. AND CAN.

31 — Enamel Mesh Bag with mosaic frame.
Silver plated. 4 ins. wide. $12.00 each
31R — 5 ins. wide. $18.00 each

32R — Enamel Mesh Bag with beautiful enamel
frame. 4 ins. wide. 24 karat finish. $30.00 each
32 — Silver plated. $27.00 each

33R — Enamel Mesh Bag. Fancy enamel frame.
4 ins. wide. 24 karat finish. $18.00 each
33 — Silver plated. $15.00 each

35 — Enamel Mesh Bag with filigree
frame. 4 ins. wide. Silver plated.
$13.50 each
36 — 5 ins. wide. $16.50 each

37R — Enamel Mesh Bag. Frame 4 ins. wide.
24 karat finish. $13.50 each

38G — Enamel Mesh Bag. Fancy frame
set with six aquamarine stones.
Antique green gold finish.
4 ins. wide. $18.00 each
39G — 5 ins. wide. $21.00 each

ILLUSTRATIONS ABOUT ONE-HALF SIZE

Ornate offerings from the Whiting & Davis catalog of 1927.

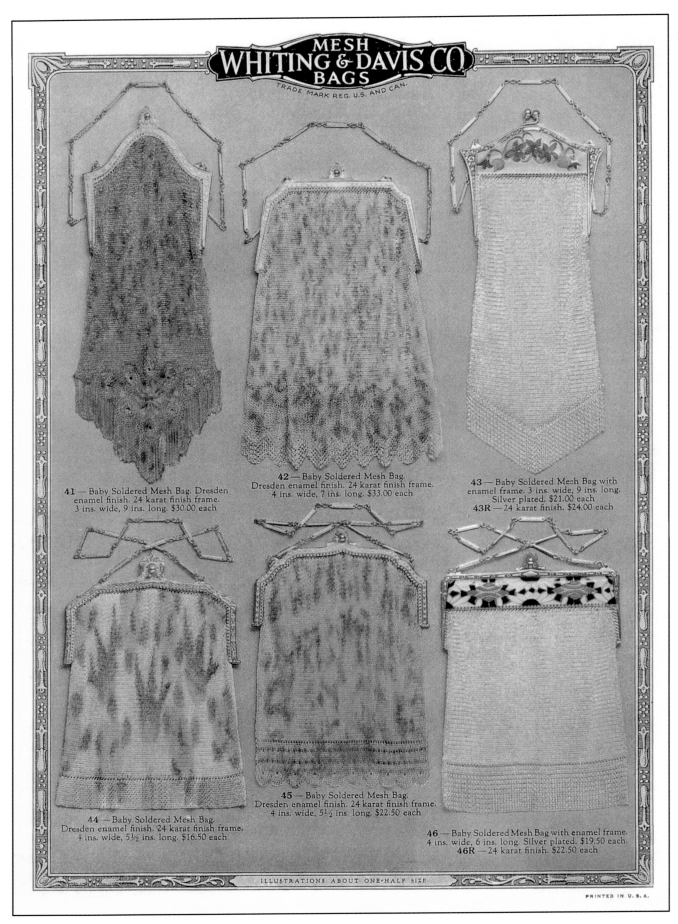

41 — Baby Soldered Mesh Bag. Dresden enamel finish. 24 karat finish frame. 3 ins. wide, 9 ins. long. $30.00 each

42 — Baby Soldered Mesh Bag. Dresden enamel finish. 24 karat finish frame. 4 ins. wide, 7 ins. long. $33.00 each

43 — Baby Soldered Mesh Bag with enamel frame. 3 ins. wide, 9 ins. long. Silver plated. $21.00 each
43R — 24 karat finish. $24.00 each

44 — Baby Soldered Mesh Bag. Dresden enamel finish. 24 karat finish frame. 4 ins. wide, 5½ ins. long. $16.50 each

45 — Baby Soldered Mesh Bag. Dresden enamel finish. 24 karat finish frame. 4 ins. wide, 5½ ins. long. $22.50 each

46 — Baby Soldered Mesh Bag with enamel frame. 4 ins. wide, 6 ins. long. Silver plated. $19.50 each
46R — 24 karat finish. $22.50 each

ILLUSTRATIONS ABOUT ONE-HALF SIZE

PRINTED IN U.S.A.

Ornate offerings from the Whiting & Davis catalog of 1927.

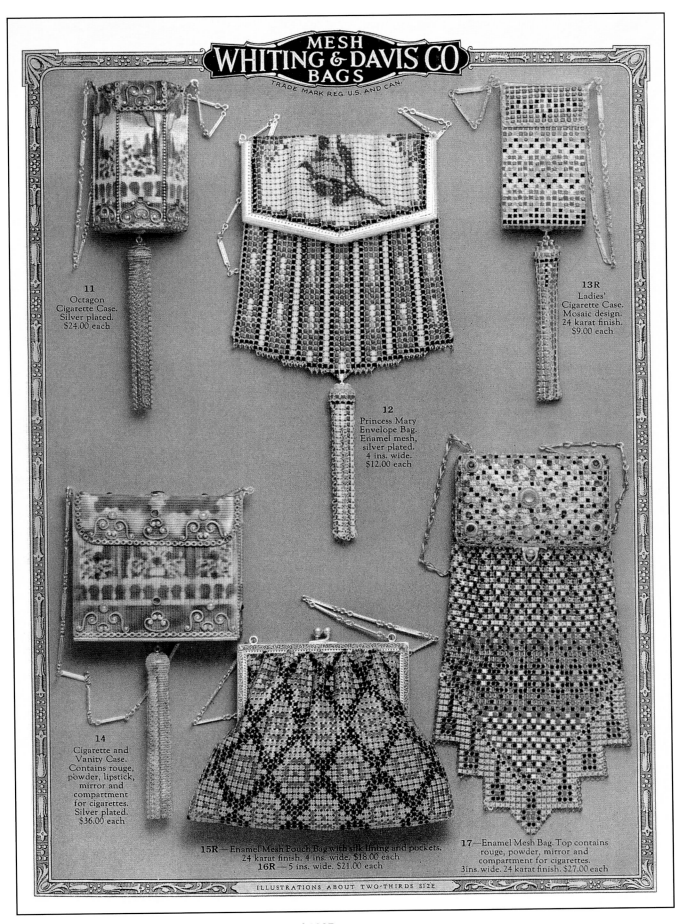

MESH WHITING & DAVIS CO BAGS

TRADE MARK REG. U.S. AND CAN.

11
Octagon
Cigarette Case.
Silver plated.
$24.00 each

13R
Ladies'
Cigarette Case.
Mosaic design.
24 karat finish.
$9.00 each

12
Princess Mary
Envelope Bag.
Enamel mesh,
silver plated.
4 ins. wide.
$12.00 each

14
Cigarette and
Vanity Case.
Contains rouge,
powder, lipstick,
mirror and
compartment
for cigarettes.
Silver plated.
$36.00 each

15R—Enamel Mesh Pouch Bag with silk lining and pockets.
24 karat finish. 4 ins. wide. $18.00 each
16R—5 ins. wide. $21.00 each

17—Enamel Mesh Bag. Top contains
rouge, powder, mirror and
compartment for cigarettes.
3 ins. wide. 24 karat finish. $27.00 each

ILLUSTRATIONS ABOUT TWO-THIRDS SIZE

Ornate offerings from the Whiting & Davis catalog of 1927.

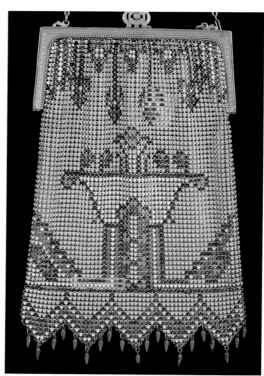

"The beauty, style, correctness, and utility of a Whiting & Davis mesh bag charms every feminine taste and age". Frozen fountain on gold, with blue metal droplets at base. A beadlite beauty, $350-400.

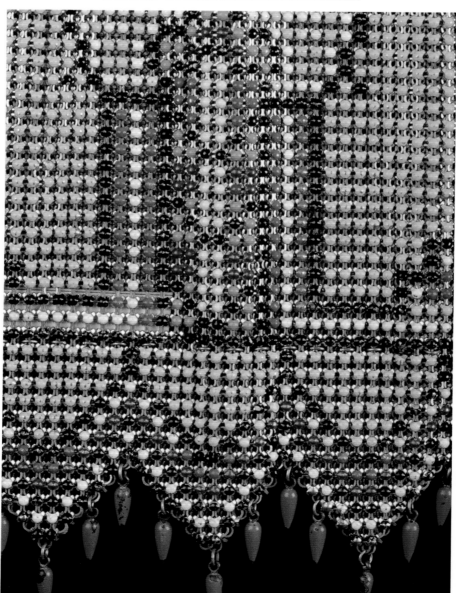

Detail: Whiting & Davis, "The Perfect Mesh".

178

Chapter 13
WHAT A MESH!
The Whiting & Davis Catalogs, 1990-1991

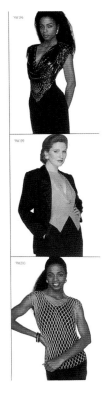

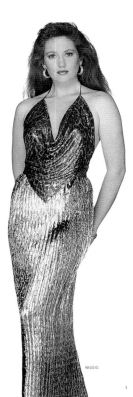

Top left: Catalog Cover

Top right: RW 194: tuxedo-style, double-breasted mesh vest with snap closure.

Bottom left: #RW 196: cowl neck halter with cap sleeves and crisscross leather ties. #RW 199: lined, ring mesh halter with cowl neckline and peplum waist. #RW 200 elaborate ring mesh lace vest.

Bottom right: #RW 103: halter with cowl neckline and V-shaped hemline.

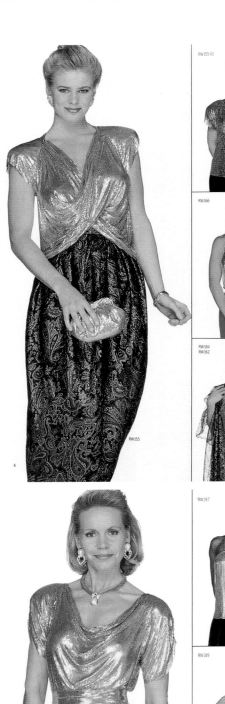
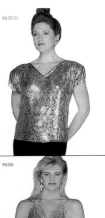
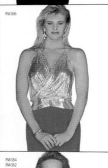
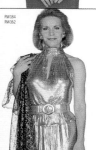
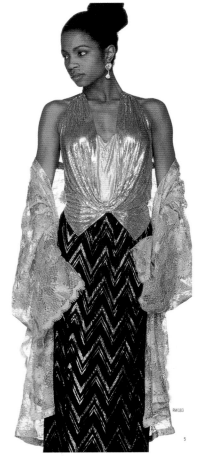

Top left: #RW 15: elegant tunic featuring softly draped, crisscrossing mesh which can be worn either in front or back. #RW 155-01: Midnight Lace/ Gold (shown with crosscross mesh in back). #RW 166: crisscross mesh halter with matching leather ties. #RW 184: updated turtleneck shell with quilted collar. #RW 162: 17-inch, fully lined mini-length skirt.

Top right: #RW 183: peplum halter with deeply draped bodice, contrasting center panel

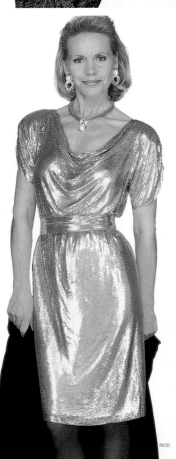
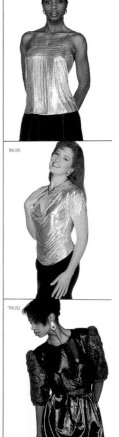
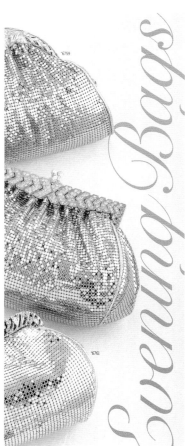

Evening Bags

Bottom left: #RW 191: classic mesh dress with softly cowled neckline and shirring on sleeves. #RW 197: mesh camisole with wide, quilted yoke and shirred zipper back. #RW 189: classic mesh blouse with softly cowled neckline. #RW 192: mesh evening blouse, matching fabric belt.

Bottom right: #6759: pouch with crystal pavè accents, top-mounted pavè liftlock, and pierced leaf frame. #6760: shoulder bag with crystal pavè chevrons and stone-set ball knobs. #6761: shoulder bag with scalloped frame, large crystal stones.

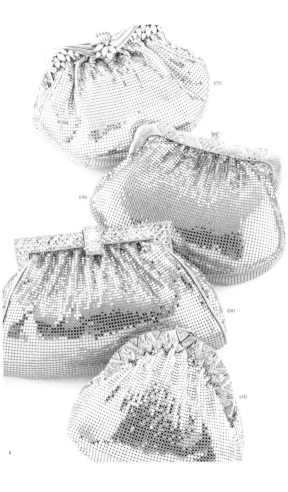

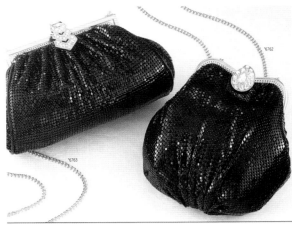

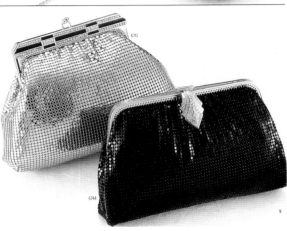

Top left: #6750: shoulder bag with curved frame adorned with crystal cluster ornaments and matching liftlock. #6749: scalloped frame shoulder bag enhanced with contrasting square and round rhinestones. #6747: shoulder bag with ornate frame and matching liftlock created with square-cut stones. #6742: domed pouch shoulder bag, frame embellished with sparkling pavè ornaments and matching liftlock.

Top right: #6763: East/West framed shoulder/clutch. #6762: Victorian camelback frame shoulder bag. #6741: Art Deco enamel and rhinestone frame bag. #6744: framed shoulder bag with shaped pavè liftlock.

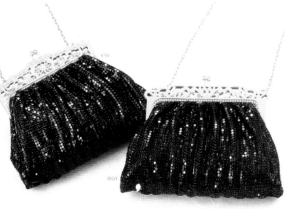

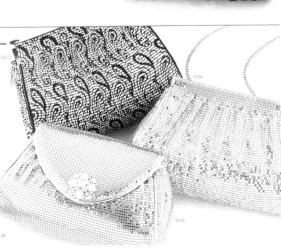

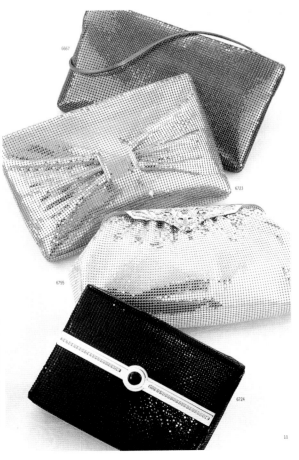

Bottom left: #6754: antique filigree frame bag with shirred mesh body. #6501 X: pierced frame bag with chain handle. #6764/6764-02: softly shirred shoulder/clutch with double magnetic snap closure and detachable handle. #6765: shirred shoulder bag with stone-set filigree ornament on curved flap.

Bottom right: #6667: shoulder bag with zipper closure and leather handle. #6723: bow front shoulder/clutch. #6755: framed clutch with decorative overlay liftlock. #6724: box shoulder/clutch with bar ornament on flap.

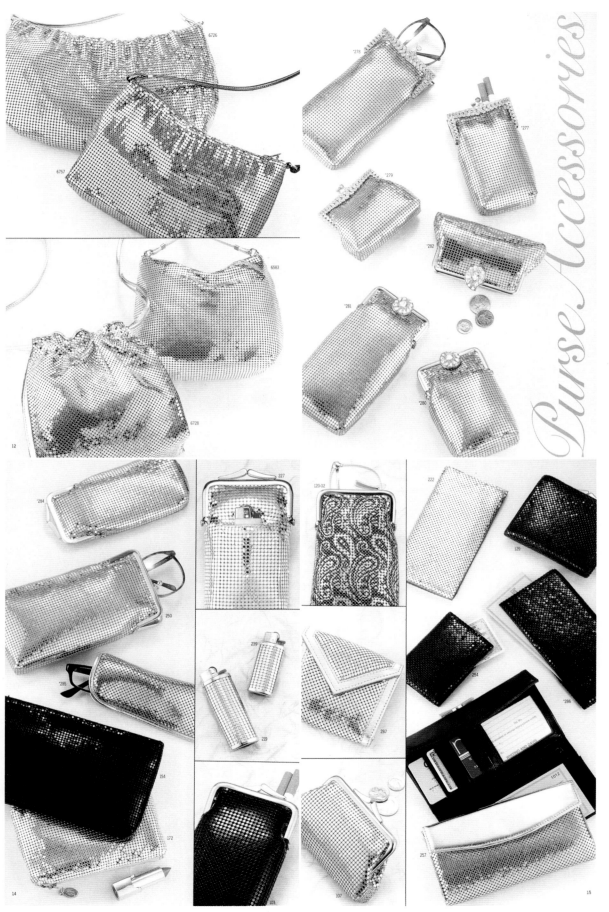

Top left: #6726: curved shoulder bag with top shirring. #6757: zippered shoulder bag with leather strap. #6583: zippered hobo bag with leather shoulder strap. #6728: draw-string shoulder bag.

Top right: #278: framed eyeglass case. #277: framed cigarette case. #279: square-shaped coin purse. #282: coin purse with ornate liftlock. #281: eyeglass case with stone-set paisley liftlock. #280: cigarette case with stone-set paisley liftlock.

Bottom left: #284: eyeglass case for half-size reading glasses. #250: double compartment eyeglass case. #285: leather-trimmed slip eyeglass case for half-size reading glasses. #154: large cosmetic clutch. #172: soft cosmetic clutch. #227: 100mm cigarette case, with leather-lined lighter pocket. #239: mesh cover for mini disposable lighter. #219: mesh cover for disposable lighter. #103: 100mm cigarette case.

Bottom right: #120-02: paisley eyeglass case. #287: tri-fold leather-trimmed wallet. #107: framed coin purse. #222: mesh checkbook cover. #129: 4-inch French purse. #254: business card case. #286: mesh checkbook cover with pen holder. #257: large secretary wallet with checkbook holder, inner zipper pocket, and framed coin section.

Purse Accessories

182

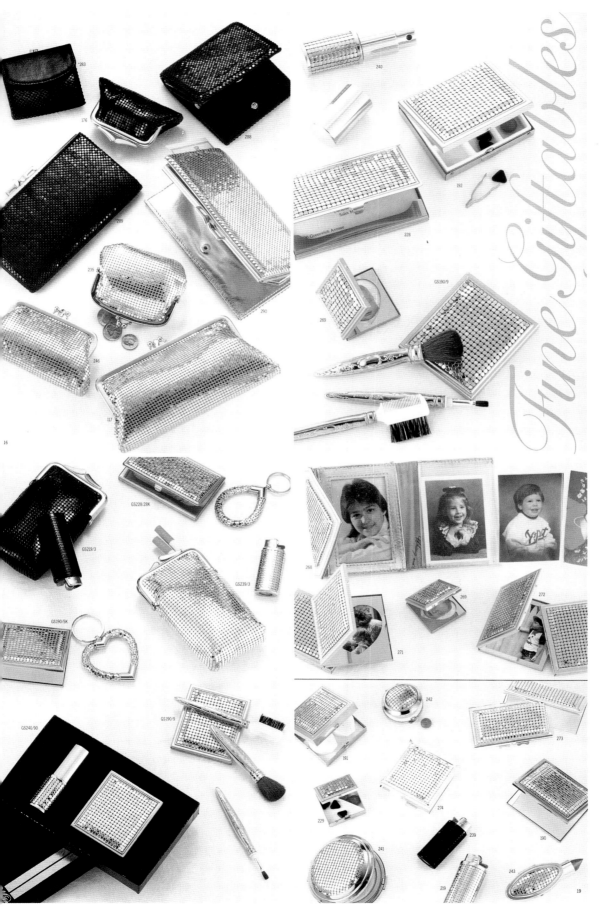

Top left: #283: tri-fold mini theatre wallet. #176: small coin purse. #288: foldover wallet with recessed frame. #289: slim, leather-lined secretary wallet with coin section. #290: large double opening wallet. #235: round coin purse. #246: double compartment coin purse. #117: cosmetic case with triple frame.

Top right: #240: refillable perfume atomizer. #192: multi-pill box. #228: business card case. #269: mini double heart picture frame. #GS 190/9: double mirror case with ornate cosmetic brushes.

Bottom left: #GS 219/3: cigarette case with standard size lighter cover. #GS 228/28 K: business card case with teardrop key ring. #GS 190/5K: double mirror case with heart key ring. #GS 239/3: cigarette case with mini lighter cover. #GS 190/9: double mirror case with ornate cosmetic brushes. #GS240/90: refillable perfume atomizer with double mirror case.

Bottom right: #268: photo brag book with pull-out picture sleeves. #271: double rectangle picture frame. #269: mini double heart picture frame. #272: double heart picture frame. #191: contact lens case. #242: round mini pill box. #273: slim double mirror case. #229: mini pill box. #274: four section pill box. #190: double mirror case. #241: powder compact with puff and protective pouch. #239: mini-mesh lighter cover. #219: standard size mesh lighter cover. #243: lipstick holder with folding mirror.

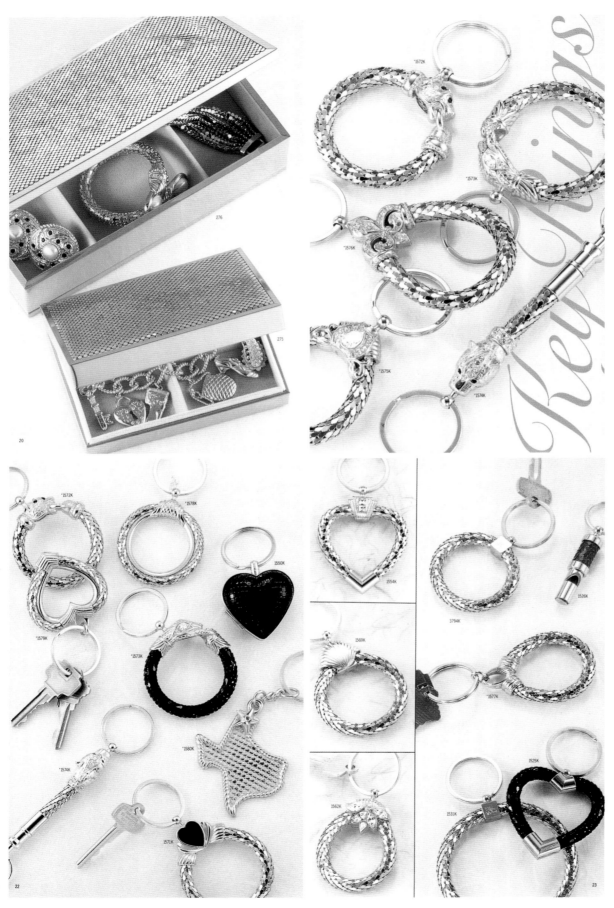

Top left: #276: large, velvet-lined jewelry box with ring keeper and four compartments. #275: small, velvet-lined jewelry box with ring keeper and two compartments.

Top right: #1572 K: leopard motif key ring. #1573 K: serpent motif key ring. #1576 K: fleur-de-lis key ring with pin-point crystal accents. #1575 K: Victorian jeweled teardrop key ring with marquise stone. #1574 K: contemporary sculpted leopard motif pull-apart key ring.

Bottom left: #1572 K: leopard motif key ring. #1578 K: round mini-mesh key ring. #1550 K: puffed heart locket key ring. #1579 K: mini-mesh heart key ring. #1573 K: serpent motif key ring with crystal stones. #1574 K: contemporary sculpted leopard motif pull-apart key ring. #1580 K: Texas State key ring with crystal star detail. #1571 K: round key ring with enamel heart ornament.

Bottom right: #1554 K: heart key ring. #1569 K: round key ring with sculpted shell ornament. #1562 K: teardrop key king ornamented with marquise-shaped rhinestones. #3794 K: round ornament key ring. #1526 K: mini whistle key ring. #1577 K: teardrop key ring with chain texture ornamentation. #1531 K: jailer's large round key ring. #1525: heart key ring.

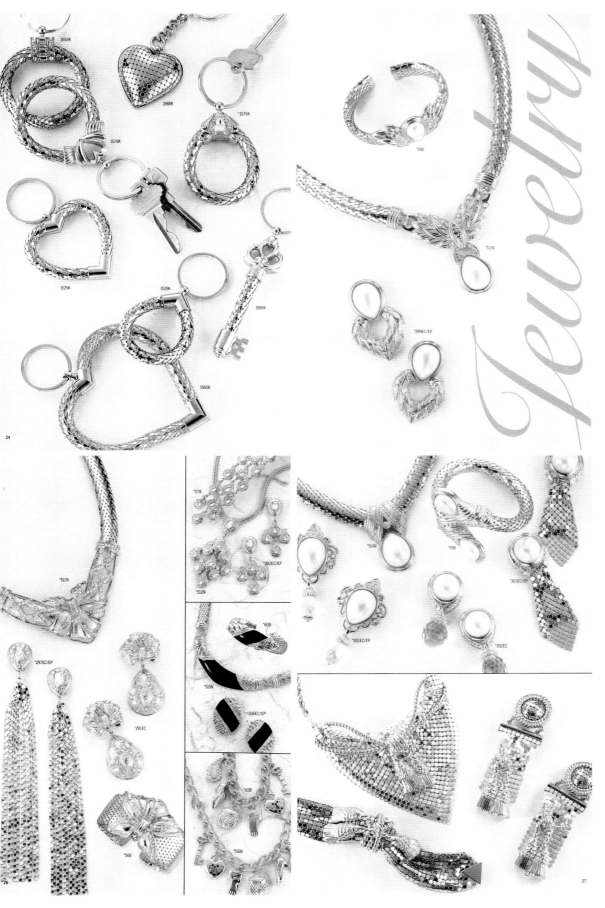

Top left: #1553 K: round key ring with crystal ornament. #1570 K: round key ring with pierced heart ornament. #1568 K: puffed heart key ring with chain. #1575 K: Victorian jeweled teardrop key ring. #1525 K: heart key ring. #1528 K: mini teardop key ring. #1565 K: Victorian-style key ring with scrollwork ornament. #1560 K: large heart key ring with chain.

Top right: #58 B: pierced leaf mesh cuff with pear-shaped pearl and crystal stone accents. #513 N: pierced leaf 17-inch mesh necklace. #299 EC/EP: pierced leaf doorknocker earring.

Bottom left: #511 N: Tsarina pavè bow on 17-inch mesh necklace. #297 EC/EP: pear-shaped crystal earring with mesh shoulder duster. #291 EC: Tsarina pavè bow earring with imperial egg drop. #56 B: Tsarina pavè bow on 1-inch mesh cuff. #57 B: linked crystal paisley bracelet. #512 N: crystal paisley chandelier pendant on 16-1/2-inch chain. #292 EC/EP: crystal paisley chandelier earring. #60 B: Victorian mesh cuff with enamel center. #515 N: Victorian 18-inch mesh necklace with enamel center. #306 EC/EP: Victorian oval earring with enamel center. #61 B: Victorian charms on twisted link bracelet. #516 N: Victorian charms on 19-inch twisted link necklace.

Bottom right: #514 N: 17-inch mesh necklace with pear-shaped pearl. #301 EC/EP: Victorian pear-shaped pearl earring. #59 B: pear-shaped pearl and mesh bypass bracelet. #303 EC/EP: pearl button earring with mesh drop. #302 EC: round pearl earring with large, faceted crystal drop. (Also shown, no catalog number: twisted rope and tassel jewelry set).

#292 EC/EP: crystal paisley chandelier earring. #295 EC: rectangular earring with square baguette stones. #291 EC: Tsarina pavè bow earring with imperial egg drop. #293 EC: large paisley button earring. #297 EC/EP: pear-shaped crystal earring with mesh shoulder duster. #294 EC: round pavè earring with mesh button center. #290 EC/EP: linked crystal pavè pendulum earring. #255 EC/EP: jeweled cluster earring with mesh button center. #298 EC/EP: round pavè swirl earring with mesh shoulder duster. #296 EC/EP:

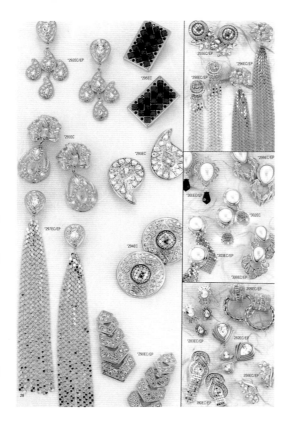

Tsarina pavè bow earring with mesh shoulder duster. #301 EC/EP: Victorian pear-shaped pearl earring with faceted stone drop. #299 EC/EP: pierced leaf doorknocker earring. #302 EC: round pearl earring with large faceted crystal drop. #303 EC/EP: pearl button earring with mesh drop. #300 EC/EP: pear-shaped pearl and lace filigree earring. #282 EC/EP: stone-set earring with pear-shaped crystal drop. #209 EC/EP: mini-mesh loop earring with baguette stone-set ornament. #282 EC/EP: large pear-shaped stone-set earring with matching crystal drop. #180 EC/EP: double loop stone-set earring with mesh drop. #256 EC/EP: asymmetrical earring with clustered crystal stones.

#313 EC: large leaf earring with mesh or stone button center. #269 EC/EP: round granulated texture earring with mesh button center. #263 EC/EP: Stone-set feather half hoop earring. #265 EC/EP: round filigree button earring with cabachon stone and woven mesh setting. #314 EC/EP: asymmetrical leaf and acorn earring. #296 EC/EP: Tsarina pavè bow earring with mesh shoulder duster. #291 EC: Tsarina pavè bow earring with imperial egg drop. #306 EC/EP: oval Victorian earring with enamel center. #305 EC/EP:

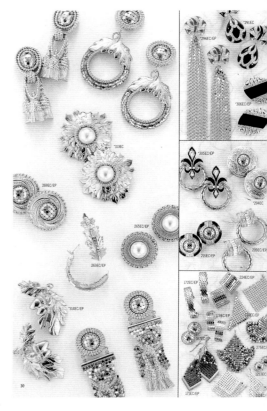

enamel fleur-de-lis earring with mesh loop. #294 EC: round pavè earring with mesh button center. #215 EC/EP: round jet enamel and pavè earring with mesh button center. #209 EC/EP: mini-mesh loop earring with baguette stone-set ornament. #172 EC/EP: large snake mesh hoop. #224 EC/EP: half hoop earring with mesh inlay. #132 EC/EP: soft mesh diamond drop earring. #167 EC/EP: large mesh button earring. #173 EC/EP: small snake mesh hoop. #275 EC/EP: soft mesh drop earring with ruffled edge. #171 EC/EP: mesh drop earring with metal ornament. #221 EC/EP: soft mesh double diamond drop earring. #1253 EC/EP: small mesh button earring. (Also shown, no catalog numbers: triple tassel earring, oak leaf hoop. double tassel earring).

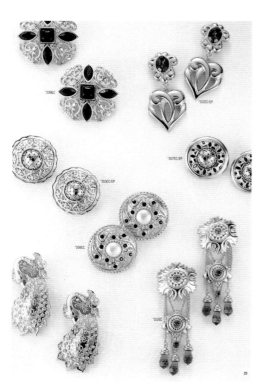

Left: #309 EC: filigree earring with large stone accents. #312 EC/EP: stone-set earring with sculpted filigree drop. #310 EC/EP: round filigree earring with mesh button center. #308 EC: paisley-textured button earring with small stone accents. #307 EC/EP: round earring with mesh button center and jet/crystal stone accents. #311 EC: chandelier earring with three stone-set pendulums. (Also shown, no catalog number: paisley earring).

Right: #8 B: double coil snake bracelet. #53 B: snake mesh bypass bracelet with leopard head ornaments. #59 B: pear-shaped pearl and mesh bypass bracelet. #10 B: round snake mesh bangle. #45 B: 1/4-inch snake mesh cuff. #36 B: mini-mesh domed cuff bracelet. #19 B: 1/2-inch snake mesh cuff. #16 B: 1-inch snake mesh cuff. #30 B: 1/2-inch snake mesh cuff with rhinestone ornaments. #47 B: elliptical mesh cuff bracelet with waved stone cluster ornament. #50 B: mesh cuff bracelet with feather ornament. #64 B: pleated mesh bracelet with clasp closure. #58 B: pierced leaf mesh cuff with pear-shaped pearl. # 60 B: Victorian mesh cuff with enamel center. #63 B: linked leaf bracelet with cabachon stone centers. #61 B: Victorian charms on twisted link bracelet. #57 B: linked crystal paisley bracelet. #56 B: Tsarina pavè bow on 1-inch mesh cuff. #62 B: linked filigree bracelet with large stone accents. (Also shown, no catalog number: twisted rope and tassel bracelet).

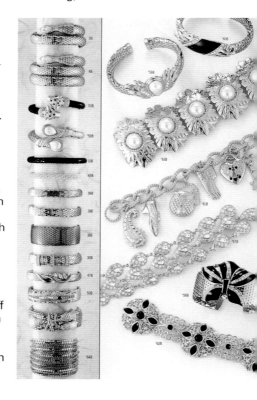

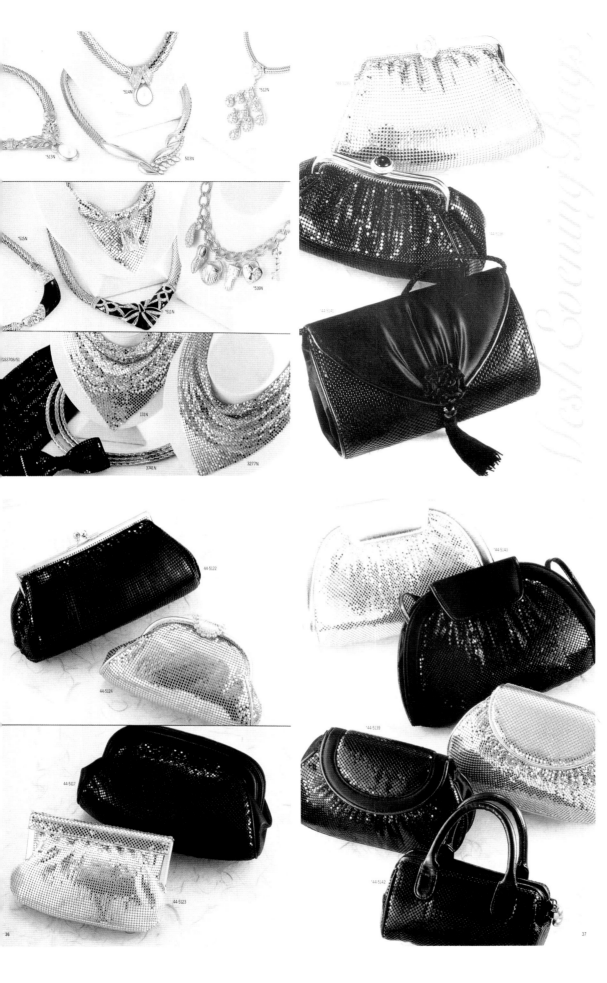

Top left: #513 N: pierced leaf 17-inch mesh necklace with pear-shaped pearl. #514 N: 17-inch mesh necklace with pear-shaped pearl. #503 N: 17-inch collar-style necklace with sculpted petals and crystal cluster ornament. #512 N: crystal paisley chandelier pendant on 16-1/2-inch chain. #515 N: Victorian 18-inch mesh necklace with enamel center. #511 N: Tsarina pavè bow on 17-inch mesh necklace. #516 N: Victorian charms on 19-inch twisted link necklace. #GS 3709/51: tuxedo-style cummerbund and bowtie. #131 N: mesh cowl. #3741 N: triple strand mini-mesh collar. #3277 N: mesh cowl. (Also shown, no catalog number: twisted rope cowl).

Top right: #44-5135: deeply shirred mesh body with shaped, piped gussets. #44-5136: curved frame bag with stone accent liftlock. #44-5141: mesh and satin V-flap clutch with satin rose ornament and beaded tassel trim.

Bottom left: #44-5122: East/West clutch with jeweled clasp. #44-5124: domed pouch with rhinestone accented liftlock. #44-5117: pouchy shoulder/clutch with trapunto-covered frame. #44-5123: elegant pouch with mesh-covered clappè frame.

Bottom right: #44-5140: domed shoulder bag with wide, magnetic tab closure. #44-5139: rounded clutch with split satin gusset and curved, satin-trimmed flap. #44-5142: structured mini-satchel with ball-and-heart zipper pull ornament.

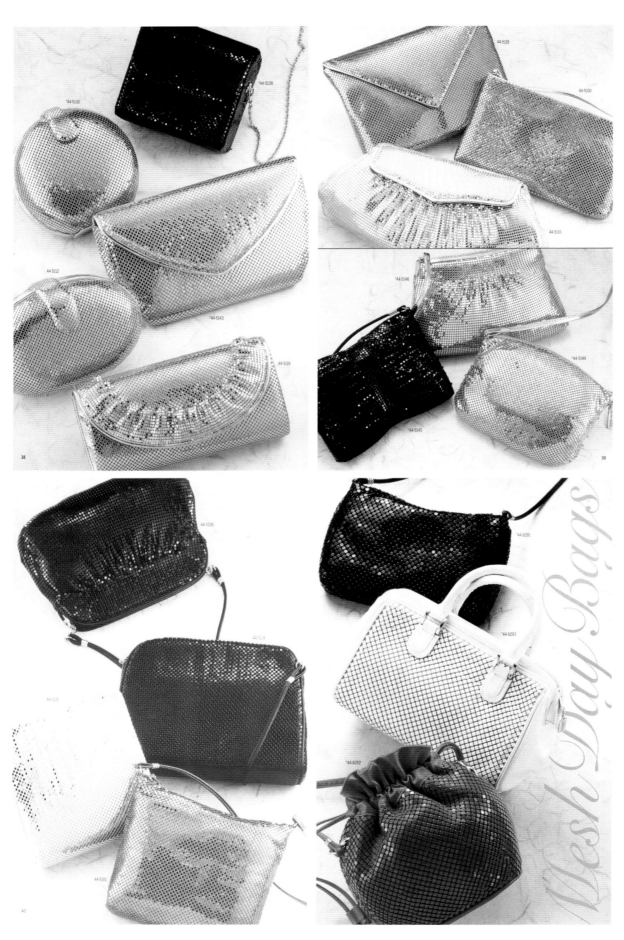

Top left: #44-5138: structured mesh barrel with half flap. #44-5132: round mesh box. #44-5143: structured clutch with piped V-flap. #44-5112: oval, mesh-covered box bag. #44-5119: envelope clutch with ruffle on half flap.

Top right: #44-5118: V-flap envelope. #44-5100: shoulder clutch with detachable handle. #44-5110: large shoulder/clutch with shaped flap. #44-5146: zip-top shoulder bag with shirring along top band. #44-5145: zip-top shoulder bag with center band. #44-5144: zip-top shoulder bag with side shirring.

Bottom left: #44-5108: small shoulder bag with facile closure. #44-5115: small shoulder bag with rolled gusset and double snap closure. #44-5114: classic shoulder bag with dome top. #44-5101: soft shoulder bag with zipper closure.

Bottom right: #44-8291: small semi-constructed East/West shoulder bag. #44-8293: stylish mini-satchel with "across-the-body" shoulder strap. #44-8292: small, pouchy drawstring with metal ornament handle attachment.

Mesh Day Bags

188

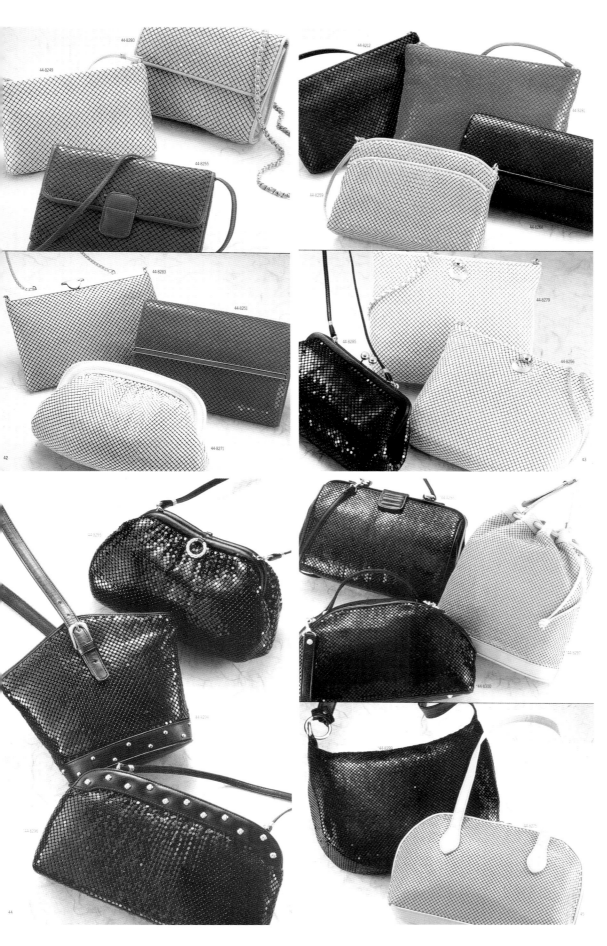

Top left: #44-8280: small flap shoulder bag with braided chain handle. #44-8249: mini shoulder/clutch. #44-8255: mini shoulder bag with magnetic snap closure and inside mirror. #44-8283: small clutch with lift-top frame. #44-8251: bar-trimmed shoulder/clutch. #44-8271: soft shoulder/clutch with trapunto-covered frame.

Top right: #44-8212: zippered shoulder/clutch. #44-8281: large clutch with recessed zipper closure. #44-8268: flap clutch with piping and detachable handle. #44-8259: piped shoulder bag with top zipper and side pocket. #44-8279: facile shoulder bag with metal ornament and adjustable braided chain handle. #44-8285: covered frame shoulder/clutch with ball knob closure. #44-8256: facile shoulder bag with metal ornament and adjustable chain handle.

Bottom left: #44-8295: saddle-back covered frame clutch in soft pouchy shape with textured gold tone ring pull. #44-8294: dome-shaped bag with front-to-back buckled shoulder strap and stud ornamentation. #44-8296: East/West clutch, curved zipper collar ornamented with rosette-style studs.

Bottom right: #44-8298: "Doctor's bag" tote with covered, stay-open frame. #44-8297: large drawstring bag with side closures. #44-8300: soft domed satchel with dog-leash detail on shoulder strap. #44-8299: oversized, crescent-shaped hobo. #44-8275: triple compartment, double handle shoulder bag.

189

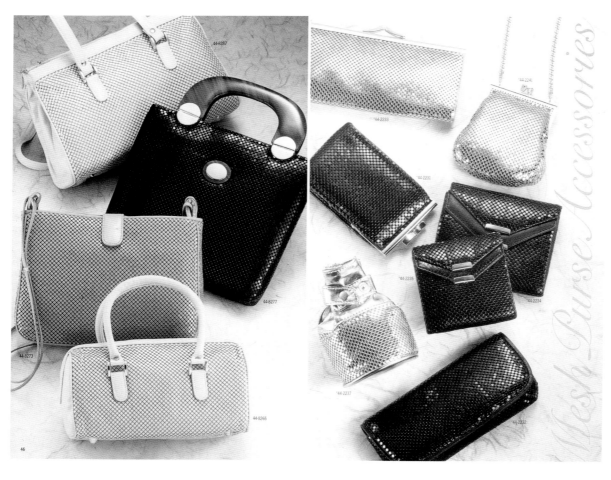

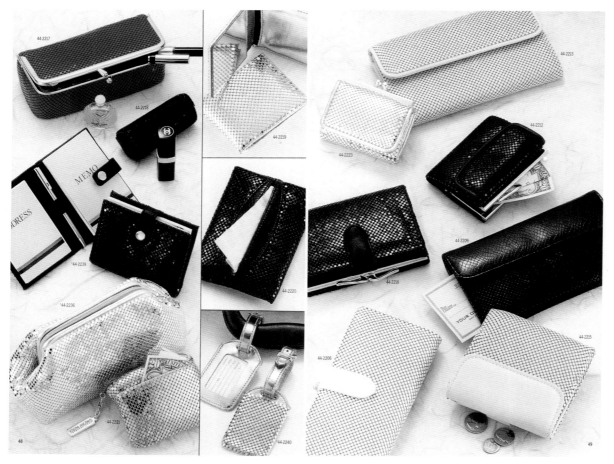

Top left: #44-8287: triple compartment tote bag with double handles. #44-8277: tote with tortoiseshell handles and ornament. #44-8273: soft triple compartment shoulder bag with mesh gusset. #44-8265: round, double handle satchel with extended zipper.

Top right: #44-2233: East/West eyeglass case with scissor-leg frame. #44-2241: small evening coin purse on long shoulder chain. #44-2231: 100mm cigarette case. #44-2234: medium-sized sleek wallet with double foldover flap closure. #44-2235: small, sleek wallet of same design. #44-2237: soft pouch for change or jewelry with double snap, wraparound strap. #44-2232: prescription-style eyeglass case with Velcró closure.

Bottom left: #44-2217: soft cosmetic case with top-opening frame and inside mirror. #44-2218: lipstick case with snap closure and inside mirror. #44-2239: small snap closure address book with matching memo pad and pen. #44-2236: travel kit-style cosmetic case. #44-2221: domed coin purse with side pocket. #44-2219: small folding mirror with inside pocket. #44-2220: travel-size tissue holder. #44-2240: carry-on luggage I.D. tag with mini-buckle tab and address window.

Bottom right: #44-2223: tri-fold framed mini wallet with double pocket bill compartment. #44-2213: large tri-fold wallet with credit card slots and checkbook cover. #44-2212: small tri-fold wallet. #44-2216: slim continental billfold with credit card slots. #44-2209: zipper back wallet with credit card slots and check holder. #44-2206: checkbook wallet with credit card slots and separate checkbook cover. #44-2215: medium-sized indexer wallet with credit card slots.

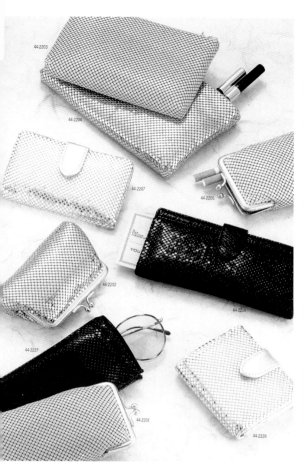

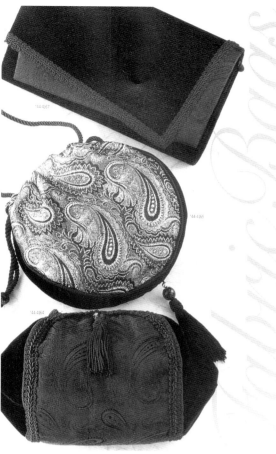

Top left: #44-2203: zippered cosmetic clutch. #44-2204: large cosmetic clutch with recessed zipper. #44-2207: credit card case with tab closure. #44-2200: 100m cigarette case. #44-2202: framed coin purse. #44-2214: checkbook cover with credit card slots. #44-2227: slip eyeglass case with expandable gusset. #44-2201: framed eyeglass/cigarette case. #44-2228: large credit card case.

Top right: #44-4167: velvet clutch with passementerie and paisley-trimmed flap. #44-4165: pouchy Victorian drawstring with jet beaded tassel trim. #44-4164: pouchy Victorian zip-top bag with passementerie trim and pearl beaded tassel.

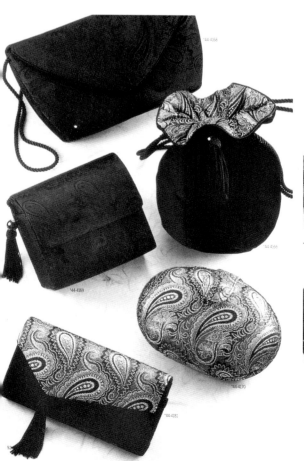

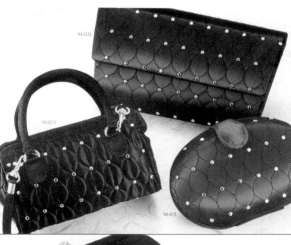

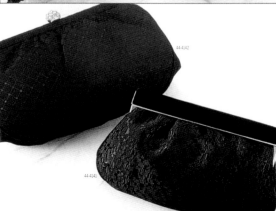

Bottom left: #44-4168: paisley jacquard clutch with V-shaped flap. #44-4169: structured paisley jacquard barrel with beaded tassel trim. #44-4166: velvet drawstring pouch with paisley lining and beaded tassel trim. #44-4181: mini clutch with angled flap and tassel trim. #44-4170: classic paisley jacquard egg.

Bottom right: #44-4172: quilted, studded clutch with angled half flap. #44-4173: quilted, studded mini satchel with detachable shoulder strap. #44-4171: quilted and studded egg. #44-4142: clutch with frame covered in geometric jacquard. #44-4141: soft clutch in luxurious jacquard with velvet-covered clappè frame.

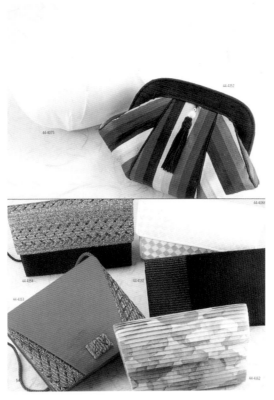

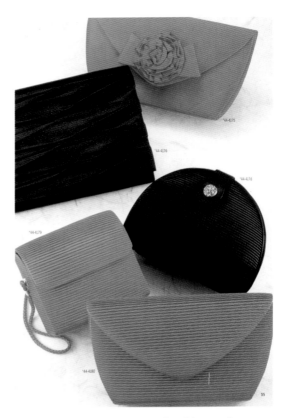

#44-4075: roomy satin moirè facile pouch. #44-4152: pouchy silk clutch. #44-4154: constructed clutch with solid silk body, multi-color metallic ribbon flap. #44-4066: angled three-quarter flap bag with rolled gusset. #44-4153: North/South silk envelope trimmed with multi-colored metallic ribbon. #44-4132: full flap clutch in rich, shiny ottoman. #44-4162: clutch in pleated chintz.

#44-4175: V-flap satin clutch with rose/bow ornament. #44-4176: full flap folded satin clutch with rolled gusset. #44-4178: domed, pleated satin box with stone button detail. #44-4179: pleated satin barrel bag. #44-4180: pleated satin clutch with V-flap.

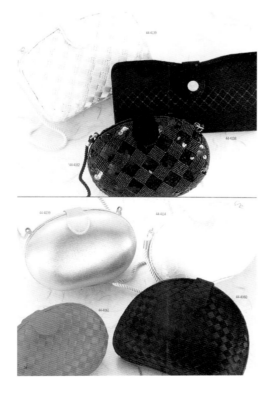

#44-4139: fan-shaped box with woven braid. #44-4138: East/West clutch in jacquard with gold tone ornament. #44-4182: classic egg with beads and sequins in basket weave pattern. #44-4039: small egg-shaped box in moirè or metallic lamé .#44-4114: lace-covered egg-shaped box bag. #44-4061: egg-shaped satin weave box. #44-4060: satin weave box with dome top and magnetic tab closure. Two inside compartments and drop-in shoulder strap.

Chapter 14
MESH-ENGERS OF THE FUTURE
The Whiting & Davis Catalogs, 2000-2001

Whiting & Davis™

FALL 2001
Volume 139.1-201-WD

1-8636

Available in:
Matte Black w/ red leather facing BK, Matte Gold w/ red leather facing MG,
Champagne w/ brown leather facing CH, Gunmetal w/ black leather facing GM
Start ship: 6/25/01

Whiting & Davis™

3mm Mesh Mirrors
1-2892 Square Flat Mesh Mirror
1-2891 Round Bubble Mesh Mirror

Both styles available in:
Gold GL, Silver SV, Black BK
Start Ship: 7/25/01

1-2892

1-2891

3mm Shirred Bubble Mesh
Start ship: 6/25/01

1-3819

Available in:
Gunmetal GM,
Black BK, Silver SV,
Gold GL

1-3820

Available in: Black BK,
Matte Gold MG,
Satin Silver SS, Gunmetal GM

1-3817 SV 1-3816 GM 1-3818 GL

3mm Flat Mesh
Available in: Silver SV, Gunmetal GM,
Gold GL, Black BK (not shown)
Start Ship: 6/25/01

Whiting & Davis™

Showroom: 320 Fifth Avenue, Suite 908 New York, NY 10001
Tel: (212) 564-1151 Fax: (212) 594-2427 Orders: 800-772-0418

Florida (954) 578-1310 **Atlanta** (404) 688-3300
Chicago (312) 836-0386 **Dallas** (214) 630-0541 **Los Angeles** (213) 627-2341

Headquarters: 1281 Andersen Drive, Suites A-C San Rafael, CA 94901
Tel: (415) 457-2595 Fax: (415) 457-2702 Orders: 800-827-1112

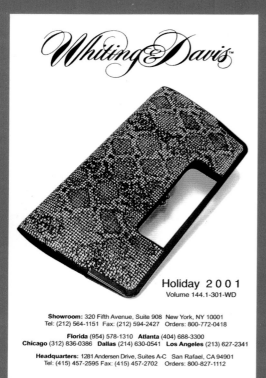

Whiting & Davis™

Holiday 2001
Volume 144.1-301-WD

Showroom: 320 Fifth Avenue, Suite 908 New York, NY 10001
Tel: (212) 564-1151 Fax: (212) 594-2427 Orders: 800-772-0418

Florida (954) 578-1310 Atlanta (404) 688-3300
Chicago (312) 836-0386 Dallas (214) 630-0541 Los Angeles (213) 627-2341

Headquarters: 1281 Andersen Drive, Suites A-C San Rafael, CA 94901
Tel: (415) 457-2595 Fax: (415) 457-2702 Orders: 800-827-1112

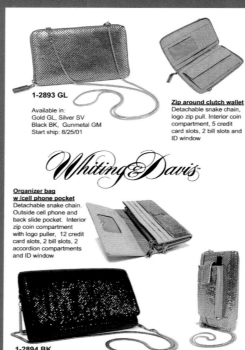

1-2893 GL

Available in:
Gold GL, Silver SV
Black BK, Gunmetal GM
Start ship: 8/25/01

Zip around clutch wallet
Detachable snake chain,
logo zip pull. Interior coin
compartment, 5 credit
card slots, 2 bill slots and
ID window

Whiting & Davis™

**Organizer bag
w /cell phone pocket**
Detachable snake chain.
Outside cell phone and
back slide pocket. Interior
zip coin compartment
with logo puller, 12 credit
card slots, 2 bill slots, 2
accordion compartments
and ID window

1-2894 BK

Available in: Black BK, Gold GL, Silver SV, Gunmetal GM Start ship: 8/25/01

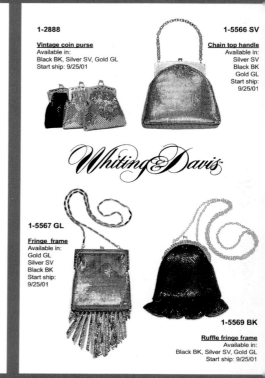

1-2888

Vintage coin purse
Available in:
Black BK, Silver SV, Gold GL
Start ship: 9/25/01

1-5566 SV

Chain top handle
Available in:
Silver SV
Black BK
Gold GL
Start ship:
9/25/01

Whiting & Davis™

1-5567 GL

Fringe frame
Available in:
Gold GL
Silver SV
Black BK
Start ship:
9/25/01

1-5569 BK

Ruffle fringe frame
Available in:
Black BK, Silver SV, Gold GL
Start ship: 9/25/01

Whiting & Davis™

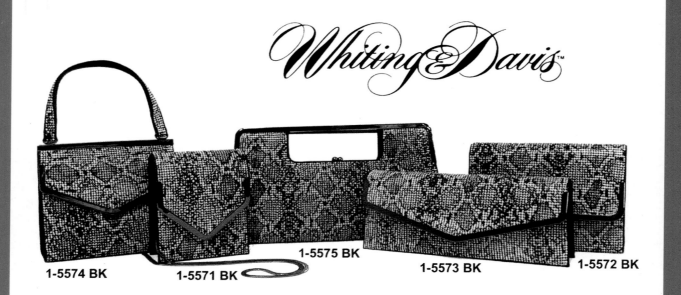

1-5574 BK **1-5571 BK** **1-5575 BK** **1-5573 BK** **1-5572 BK**

3mm Python Enamel Pattern
Black and bone python pattern with red jacquard logo lining
Start ship: 8/25/01

Whiting & Davis

Handbags

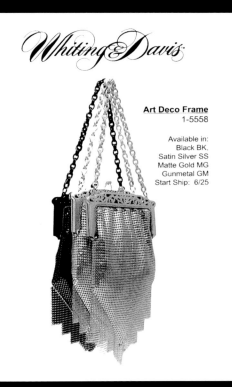

Whiting & Davis

Art Deco Frame
1-5558

Available in:
Black BK,
Satin Silver SS
Matte Gold MG
Gunmetal GM
Start Ship: 6/25

Whiting & Davis

Showroom
320 Fifth Ave., Suite 908
New York, NY 10001
Tel: (212) 564-1151
Fax: (212) 594-2427
Orders: 800-772-0418

Headquarters
1281 Andersen Dr., Suites A-C
San Rafael, CA 94901
Tel: (415) 457-2595
Fax: (415) 457-2702
Orders: 800-827-1112

Florida
(954) 916-0018

Atlanta
(404) 688-3300

Chicago
(312) 836-0386

Dallas
(214) 630-0541

Los Angeles
(213) 627-2341

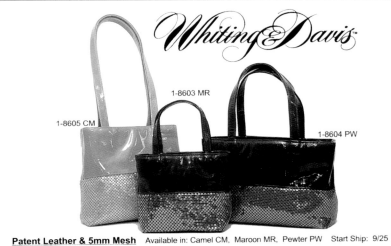

Whiting & Davis

1-8603 MR

1-8605 CM

1-8604 PW

Patent Leather & 5mm Mesh Available in: Camel CM, Maroon MR, Pewter PW Start Ship: 9/25

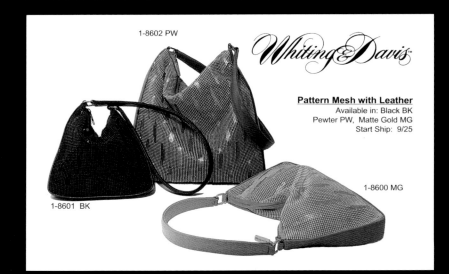

1-8602 PW

Whiting & Davis

Pattern Mesh with Leather
Available in: Black BK
Pewter PW, Matte Gold MG
Start Ship: 9/25

1-8600 MG

1-8601 BK

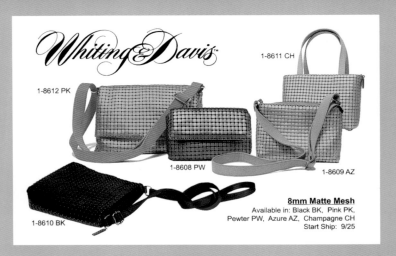

Whiting & Davis

1-8611 CH

1-8612 PK

1-8608 PW

1-8609 AZ

1-8610 BK

8mm Matte Mesh
Available in: Black BK, Pink PK,
Pewter PW, Azure AZ, Champagne CH
Start Ship: 9/25

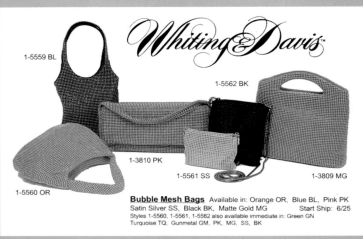

Whiting & Davis

1-5559 BL

1-5562 BK

1-3810 PK

1-5561 SS

1-3809 MG

1-5560 OR

Bubble Mesh Bags Available in: Orange OR, Blue BL, Pink PK
Satin Silver SS, Black BK, Matte Gold MG Start Ship: 6/25
Styles 1-5560, 1-5561, 1-5562 also available immediate in: Green GN
Turquoise TQ, Gunmetal GM, PK, MG, SS, BK

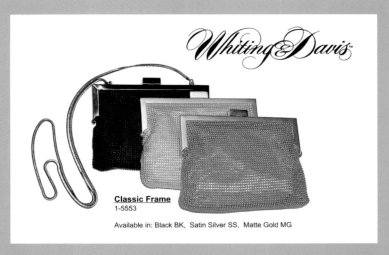

Whiting & Davis

Classic Frame
1-5553

Available in: Black BK, Satin Silver SS, Matte Gold MG

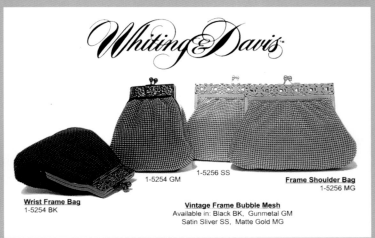

Whiting & Davis

Wrist Frame Bag
1-5254 BK

1-5254 GM

1-5256 SS

Frame Shoulder Bag
1-5256 MG

Vintage Frame Bubble Mesh
Available in: Black BK, Gunmetal GM
Satin Sliver SS, Matte Gold MG

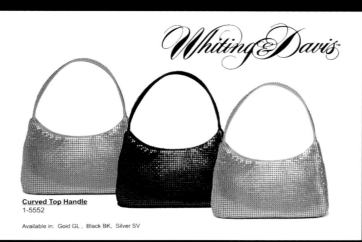

Curved Top Handle
1-5552

Available in: Gold GL , Black BK, Silver SV

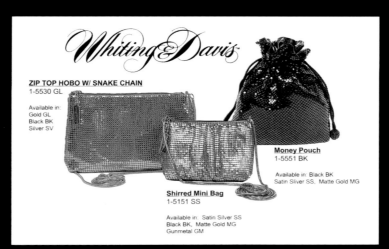

ZIP TOP HOBO W/ SNAKE CHAIN
1-5530 GL

Available in:
Gold GL
Black BK
Silver SV

Money Pouch
1-5551 BK

Available in: Black BK
Satin Sliver SS, Matte Gold MG

Shirred Mini Bag
1-5151 SS

Available in: Satin Silver SS
Black BK, Matte Gold MG
Gunmetal GM

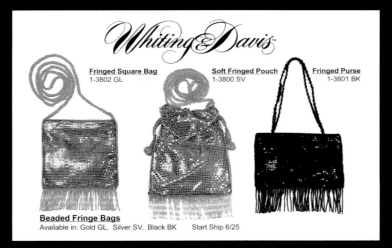

Fringed Square Bag
1-3802 GL

Soft Fringed Pouch
1-3800 SV

Fringed Purse
1-3801 BK

Beaded Fringe Bags
Available in: Gold GL, Silver SV, Black BK Start Ship 6/25

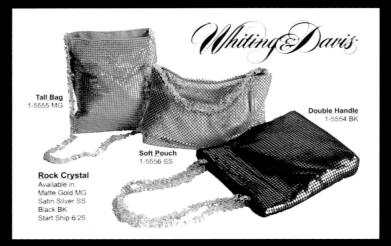

Tall Bag
1-5555 MG

Double Handle
1-5554 BK

Soft Pouch
1-5556 SS

Rock Crystal
Available in:
Matte Gold MG
Satin Silver SS
Black BK
Start Ship 6/25

197

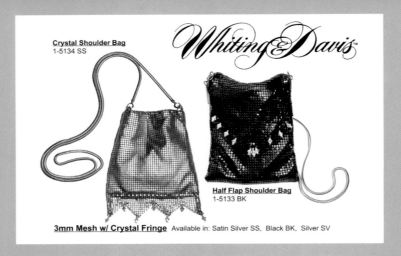

Crystal Shoulder Bag
1-5134 SS

Half Flap Shoulder Bag
1-5133 BK

3mm Mesh w/ Crystal Fringe Available in: Satin Silver SS, Black BK, Silver SV

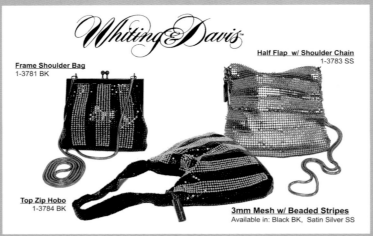

Frame Shoulder Bag
1-3781 BK

Half Flap w/ Shoulder Chain
1-3783 SS

Top Zip Hobo
1-3784 BK

3mm Mesh w/ Beaded Stripes
Available in: Black BK, Satin Silver SS

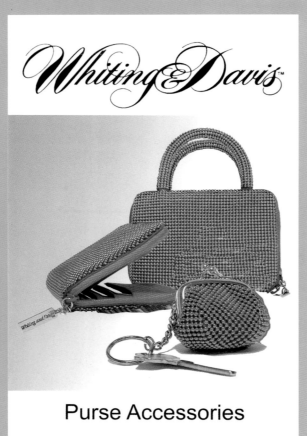

Purse Accessories

Showroom
320 Fifth Ave., Suite 908
New York, NY 10001
Tel: (212) 564-1151
Fax: (212) 594-2427
Orders: 800-772-0418

Headquarters
1281 Andersen Dr., Suites A-C
San Rafael, CA 94901
Tel: (415) 457-2595
Fax: (415) 457-2702
Orders: 800-827-1112

Florida
(954) 916-0018

Atlanta
(404) 688-3300

Chicago
(312) 836-0386

Dallas
(214) 630-0541

Los Angeles
(213) 627-2341

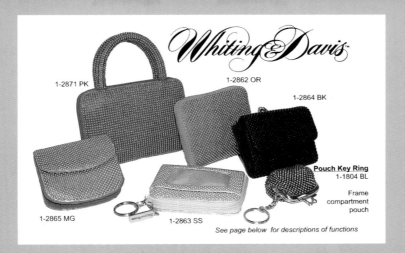

Whiting & Davis™

1-2871 PK

1-2862 OR

1-2864 BK

Pouch Key Ring
1-1804 BL

Frame
compartment
pouch

1-2865 MG

1-2863 SS

See page below for descriptions of functions

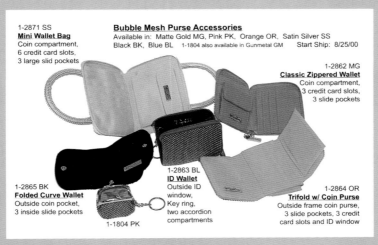

1-2871 SS
Mini Wallet Bag
Coin compartment,
6 credit card slots,
3 large slid pockets

Bubble Mesh Purse Accessories
Available in: Matte Gold MG, Pink PK, Orange OR, Satin Silver SS
Black BK, Blue BL 1-1804 also available in Gunmetal GM Start Ship: 8/25/00

1-2862 MG
Classic Zippered Wallet
Coin compartment,
3 credit card slots,
3 slide pockets

1-2865 BK
Folded Curve Wallet
Outside coin pocket,
3 inside slide pockets

1-2863 BL
ID Wallet
Outside ID
window,
Key ring,
two accordion
compartments

1-1804 PK

1-2864 OR
Trifold w/ Coin Purse
Outside frame coin purse,
3 slide pockets, 3 credit
card slots and ID window

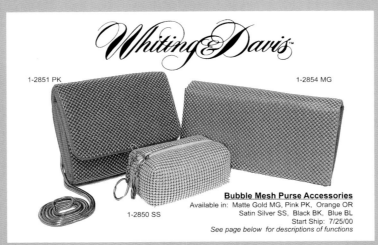

Whiting & Davis™

1-2851 PK

1-2854 MG

Bubble Mesh Purse Accessories
Available in: Matte Gold MG, Pink PK, Orange OR
Satin Silver SS, Black BK, Blue BL
Start Ship: 7/25/00
See page below for descriptions of functions

1-2850 SS

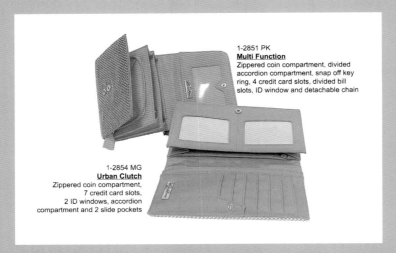

1-2851 PK
Multi Function
Zippered coin compartment, divided
accordion compartment, snap off key
ring, 4 credit card slots, divided bill
slots, ID window and detachable chain

1-2854 MG
Urban Clutch
Zippered coin compartment,
7 credit card slots,
2 ID windows, accordion
compartment and 2 slide pockets

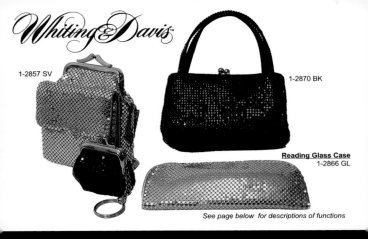

Whiting&Davis™

1-2857 SV

1-2870 BK

Reading Glass Case
1-2866 GL

See page below for descriptions of functions

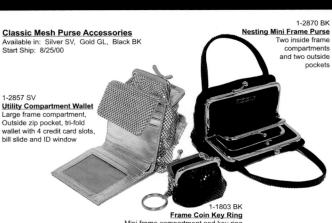

Classic Mesh Purse Accessories
Available in: Silver SV, Gold GL, Black BK
Start Ship: 8/25/00

1-2870 BK
Nesting Mini Frame Purse
Two inside frame compartments and two outside pockets

1-2857 SV
Utility Compartment Wallet
Large frame compartment, Outside zip pocket, tri-fold wallet with 4 credit card slots, bill slide and ID window

1-1803 BK
Frame Coin Key Ring
Mini frame compartment and key ring

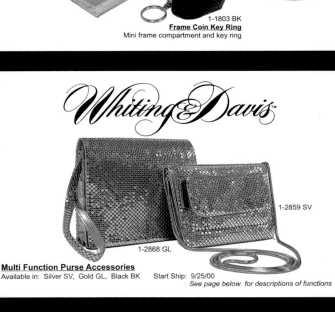

Whiting&Davis™

1-2859 SV

1-2868 GL

Multi Function Purse Accessories
Available in: Silver SV, Gold GL, Black BK

Start Ship: 9/25/00
See page below for descriptions of functions

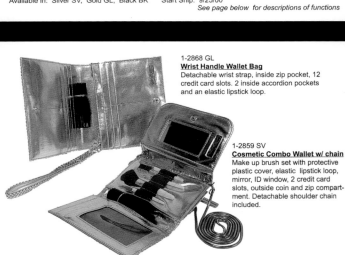

1-2868 GL
Wrist Handle Wallet Bag
Detachable wrist strap, inside zip pocket, 12 credit card slots. 2 inside accordion pockets and an elastic lipstick loop.

1-2859 SV
Cosmetic Combo Wallet w/ chain
Make up brush set with protective plastic cover, elastic lipstick loop, mirror, ID window, 2 credit card slots, outside coin and zip compartment. Detachable shoulder chain included.

Whiting & Davis™

1-2858 SV

1-2861 BK

1-2853 GL

1-2856 GL

Purse Accessories
Available in: Silver SV, Gold GL, Black BK
Start Ship: 6/25/00

See page below for descriptions of functions

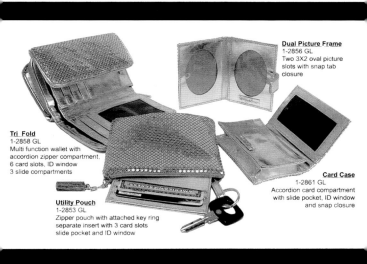

Dual Picture Frame
1-2856 GL
Two 3X2 oval picture slots with snap tab closure

Tri Fold
1-2858 GL
Multi function wallet with accordion zipper compartment, 6 card slots, ID window 3 slide compartments

Utility Pouch
1-2853 GL
Zipper pouch with attached key ring separate insert with 3 card slots slide pocket and ID window

Card Case
1-2861 GL
Accordion card compartment with slide pocket, ID window and snap closure

Whiting & Davis™

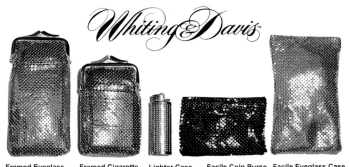

Framed Eyeglass Case w/ Pocket
1-2352 GL

Framed Cigarette Case w/ Pocket
1-2242 SV

Lighter Case
Lighter not included
1-2802 SV

Facile Coin Purse
1-2313 BK

Facile Eyeglass Case
1-2318 GL

Available in: Gold GL, Silver SV, Black BK Styles1-2313 & 1-2318 also available in Green GR, Pink PK, Turquoise TQ

Whiting & Davis™

Cosmetic Accessories
Available in: Gold GL, Silver SV, Black BK

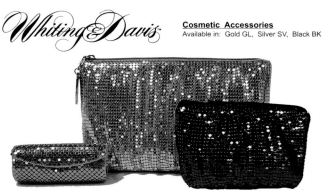

Lipstick Case w/ Mirror
1-2218 GL

Shirred Cosmetic Case
1-2221 SV

Shirred Lipstick /Coin Case
1-2251 BK

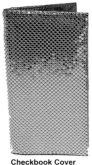

Checkbook Cover
1-2322 SV

Wallet w/Checkbook Cover
1-2226 BK

Classic Purse Accessories
Available in: Silver SV, Black BK, Gold GL

Framed French Purse
1-2224 GL

Whiting & Davis

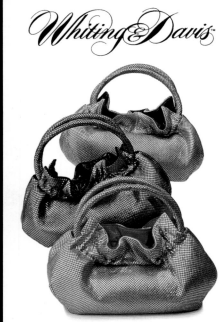

143.1-301-WD

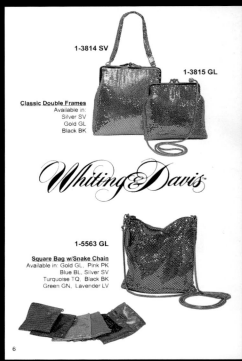

1-3814 SV

1-3815 GL

Classic Double Frames
Available in:
Silver SV
Gold GL
Black BK

Whiting & Davis

1-5563 GL

Square Bag w/Snake Chain
Available in: Gold GL, Pink PK
Blue BL, Silver SV
Turquoise TQ, Black BK
Green GN, Lavender LV

6

1-5552

Curved Top Handle
Available in:
Lavender LV
Green GN
Black BK
Pink PK
Turquoise TQ
Satin Silver SS
Blue BL
Matte Gold MGL

Whiting & Davis

1-8616

Hobo Shoulder Bag
Available in:
Lavender LV
Pink PK
Blue BL
Black BK
Matte Gold MG
Green GN
Satin Silver SS
Turquoise TQ
Gunmetal GM
(GM not shown)

8

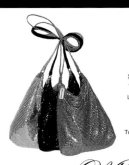

1-5531

Small Hobo
Available in:
Black BK
Lavender LV
Silver SV
Green GN
Blue BL
Pink PK
Turquoise TQ
Gold GL

Whiting & Davis

1-8629

Soft Mesh Sling
Available in:
Black BK
Blue BL
Pink PK
Turquoise TQ
Lavender LV
Gunmetal GM
Green GN
Gold GL

9

Index